AFTER THE STORM

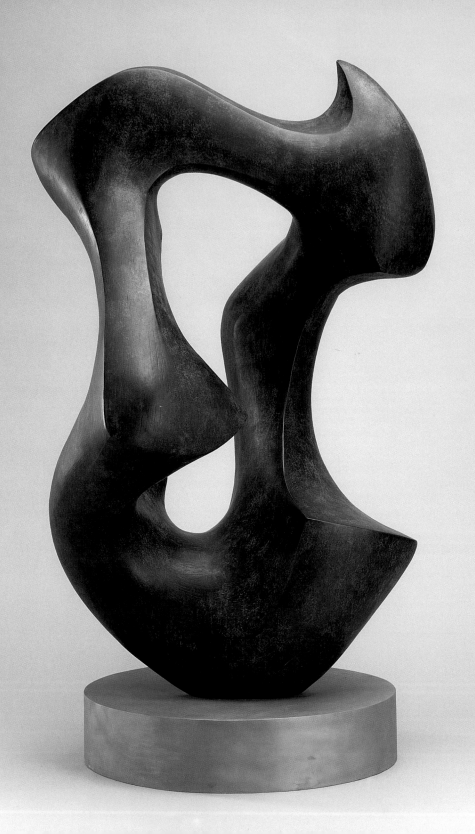

AFTER THE STORM

The Eiteljorg Fellowship for Native American Fine Art, 2001

Edited by W. Jackson Rushing III

*Eiteljorg Museum of
American Indians and Western Art
Indianapolis*

*in association with
University of Washington Press
Seattle and London*

Eiteljorg Museum of American Indians and Western Art, White River State Park, 500 West Washington Street, Indianapolis, Ind. 46204-2707, U.S.A. (317) 636-9378; www.eiteljorg.org

Published in conjunction with an exhibition of the same title, November 10, 2001–January 27, 2002

The exhibition and catalog were made possible by the generous support of Lilly Endowment, Inc., an Indianapolis-based foundation that supports the causes of community development, education, and religion. Additional support was provided by Time Warner Cable.

Photography by Dirk Bakker, Artbook, Huntington Woods, Mich., unless otherwise noted

Printed in China
Design by Michelle Dunn Marsh
Cover illustration: Allan Houser, *Silent Observer*

Library of Congress Cataloging-in-Publication Data

After the storm : the Eiteljorg Fellowship for Native American Fine Art, 2001 / edited by W. Jackson Rushing III.
p. cm.
Published in conjunction with an exhibition of same title, Nov. 10, 2001 to Jan. 27, 2002.
Includes bibliographical references.
ISBN 0-295-98174-1 (alk. paper)
1. Indian art—North America—20th Century—Exhibitions. 2. Art, American—20th century—Exhibitions. 3. Eiteljorg Museum of American Indians and Western Art—Funds and scholarships. I. Rushing, W. Jackson. II. Eiteljorg Museum of American Indians and Western Art.
N6538.A4 A34 2001
704.03'97'007477252—dc21 2001041480

The paper used in this publication is acid free and recycled from 10 percent post-consumer and at least 50 percent pre-consumer waste. It meets the minimum requirements of the American National Standard for Information Sciences—Permanence of Paper for Printed Library Materials, ANSI Z39.48-1984.

Contents

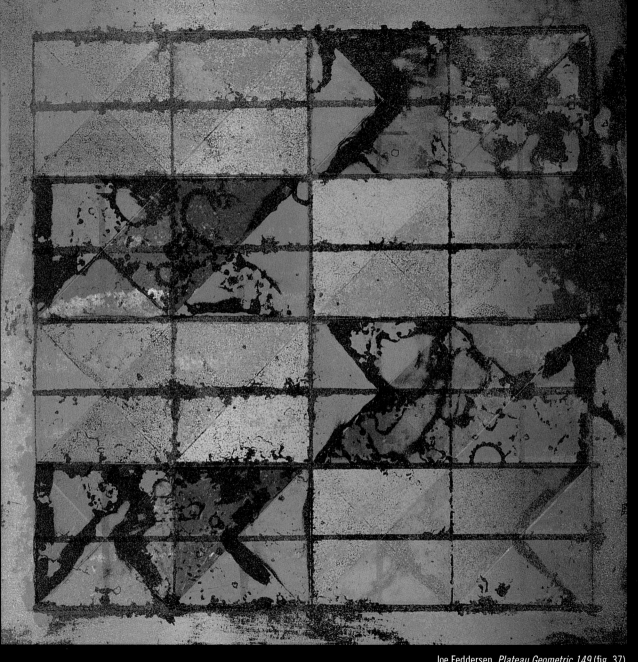

Joe Feddersen, *Plateau Geometric 149* (fig. 37)

Acknowledgments

The Eiteljorg Museum of American Indians and Western Art rests between two cultures. The struggle and hardships that formed our United States have left a residue of uncertainty, sometimes anger, and often cautious separation between Native Americans and the dominant culture. For museums, this condition—a sort of dynamic tension—can stimulate creativity. When, however, the weight and values of unique cultural experience collide with the pressure to succumb to a "universal" culture, only those who suffer that conflict can give it voice and poetic image.

The Eiteljorg Fellowship for Native American Fine Art seeks to bring those voices, those poetic images, to national attention. The term "fellowship" gives this effort meaning. We wish to express our deeply felt gratitude to everyone contributing to this effort.

At the core of the Fellowship lie the Indianapolis-based Lilly Endowment, Inc., and the people of Indianapolis. Without their encouragement and enthusiastic support, no effort of this magnitude would be possible.

Many friends in the field have helped to shape and support the Fellowship. As in past years, our Native American Council provided guidance and insight. We also wish to thank the fellows and scholars in the first Fellowship cycle: selectors Kay WalkingStick (Cherokee), Gerald McMaster (Plains Cree), and Bruce Bernstein and inaugural fellows Lorenzo Clayton (Navajo), Truman Lowe (Ho-Chunk), Marianne Nicolson (Kwakwaka'wakw), Rick Rivet (Métis/Dene), and Jaune Quick-to-See Smith (Flathead). Their advice has greatly enriched our second effort.

The common denominator of this exhibition, diverse in its media, scale, and scope, is a wonderful elegance. For that we thank this year's fellowship awardees: Rick Bartow (Yurok/Mad River Band), Joe Feddersen (Colville Confederated Tribes), Teresa Marshall (Mi'kmaq), Shelley Niro (Bay of Quinte Mohawk), and Susie Silook (Siberian Yupik/Inupiaq). The excellence of these artists encourages us all to take notice and to speak for the beauty and powerful experience their work offers.

When we realized that no realistic appraisal of Native American fine art was possible without acknowledging the enormous contributions of Allan Houser (Chiricahua Apache) as a maker and teacher, the members of the Houser/Haozous family and the staff of Allan Houser Inc. made Allan's selection as master artist possible. Their support carries on the Houser family's tradition of generosity to this community.

Selecting awardees is a demanding and inspiring task. Our panel for this round performed with knowledgeable grace and determination. Fellows were chosen from an outstanding group of nominees by Truman Lowe (Ho-Chunk), curator of contemporary art at the National Museum of the American Indian; Sara Bates (Cherokee), artist and former

curator at American Indian Contemporary Arts in San Francisco; and Colleen Cutschall (Lakota), professor of visual art at Brandon University.

The excellent contributions to the publication you have in hand were selected and edited by W. Jackson Rushing III, professor of art history and art department chair at the University of Houston. The insightful essays are by Rushing; Janet Berlo, Susan B. Anthony Professor of Gender and Women's Studies and professor of art history at the University of Rochester; Colleen Cutschall (Lakota), professor of visual art at Brandon University; Lee-Ann Martin (Mohawk), independent curator and critic, previously head curator at the MacKenzie Art Gallery in Regina, Saskatchewan, and curator-in-residence for contemporary Indian art at the Canadian Museum of Civilization; and Carol Podedworny, director and curator of the University of Waterloo Art Gallery in Waterloo, Ontario. Dirk Bakker, whose photography graces this publication, performed many small miracles. We also wish to acknowledge the University of Washington Press and its director, Patrick Soden, for their impressive contributions to design and publication. Those who have brought this publication to life did so under unusually difficult circumstances. For their heroic efforts, we are indeed grateful.

Finally, let me thank our board and entire staff. They—especially Jennifer Complo McNutt, Marjorie Jack, Christie Kirsch, Steve Sipe, and John Vanausdall—have contributed more to this project than can be imagined. This is indeed a fellowship, and we are deeply grateful to all those who have made it so.

—ARNOLD JOLLES
Vice President and Chief Curatorial Officer
Eiteljorg Museum of American Indians and Western Art
Indianapolis

As the Eiteljorg Museum of American Indians and Western Art brings to fruition the second round of the Eiteljorg Fellowship for Native American Fine Art, I am reminded of something the artist Truman Lowe once shared with me. He described a rainstorm as a clearing of the path. After the storm, the way is easier to travel. The Eiteljorg Fellowship is meant to be a rainstorm, clearing the path for five of today's best artists who are Native American, so they may have greater influence and more visibility within the mainstream contemporary art world.

In this second round, as in the first, talented and dedicated individuals have come together as jurors and writers to make the rainstorm and forge a path for this aesthetically and culturally diverse group of artists. Their efforts will ensure wide distribution of this publication and will encourage dialogue on the issues and challenges faced by Native American artists. We hope that such dialogue will include both audiences and artists and will take many forms—from the visual to the verbal, and from intimate conversation to the creation of monumental works of art.

Our colleagues are building on the successes of the first fellowship in 1999. In that cycle, the Eiteljorg Museum added twenty-one works of art to its permanent collection. These artworks have helped to illuminate a path, trod by many people of diverse backgrounds, that leads to more open ways of seeing and thinking. Along this path, divergent forces meet and intersect. One of the most remarkable crosses in the road occurs when those who come to the exhibition because they love contemporary art encounter those who come because they love Native American art and culture. As these different tastes intersect and commingle, a new potential exists to wash away some of the stereotypes and misperceptions that can influence the interpretation of contemporary art.

The Eiteljorg Museum strives to be an anchor for the individual efforts the Fellowship promotes. More artists applied during the second fellowship cycle than during the first. More institutions are interested in seeing or displaying the exhibition or making similar acquisitions and exhibitions of their own. More critics and historians are making note of the artists involved in these efforts. Through all its efforts, the Museum may have the privilege of being responsible for the preservation and presentation of one of the strongest collections of Native American fine art in the world. The rainstorm may dissolve the distinction between Native American contemporary fine artist and, simply, contemporary artist.

A critical aspect of clearing this path will be to maintain the momentum created by these biennial exhibitions using the collection the Eiteljorg Museum will acquire over the next decade. Our commitment to this cause is not one that ends with the close of an exhibition or the end of the various related public programs. The exhibition, the awards, and the artists all will influence the Museum's course. On this path, the Eiteljorg Museum promises to continue to learn through exploration of the ideas presented by our contemporary artists. In the end, what was once uncharted territory— with its twists and turns, false starts and rugged terrain—will become a familiar trail for generations to come.

—JENNIFER COMPLO McNUTT
Curator of Contemporary Art
Eiteljorg Museum of American Indians and Western Art
Indianapolis

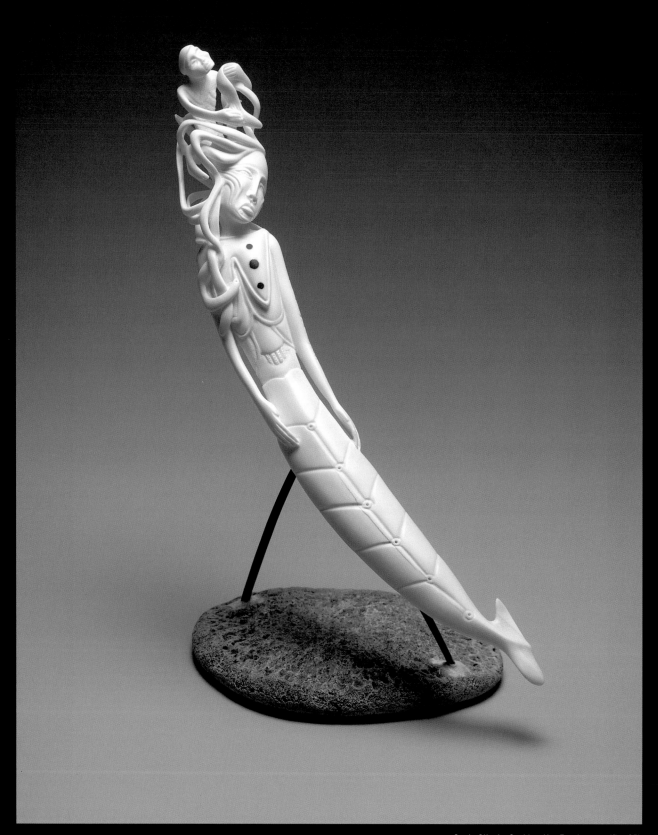

Susie Silook, *Seeking Her Forgiveness* (fig. 65)

On Patronage, Artistic Evolution, and Aesthetic Resolution

W. Jackson Rushing III

In 1999 the Eiteljorg Museum of American Indians and Western Art in Indianapolis inaugurated, with the generous support of the Lilly Endowment, Inc., the Eiteljorg Fellowship for Native American Fine Art. Each biennial program, developed by the Museum in consultation with its board and its Native American Council, culminates in an exhibition that honors a distinguished senior artist and five contemporary fine artists whose achievements warrant meritorious recognition. Each of the five fellows, who are selected by an independent jury, receives a $20,000 honorarium to facilitate his or her continued growth as a creative artist. The exhibition is documented with a scholarly catalog befitting the quality of the selected work, and the Museum acquires new work for its outstanding permanent collection of contemporary Native American art. Each fellowship cycle is unique, obviously, but the mission of the program is constant. As John Vanausdall, president and CEO of the Eiteljorg Museum, stated in 1999, "The heart of the program is the idea of fellowship itself: an alliance of scholars, curators, artists, teachers, collectors, and contributors who have come together to encourage and support Native American contemporary fine art and bring it the visibility it deserves." Any cross-section of artists has a natural and desirable level of competitive spirit, and yet, the community of contemporary Native American and Canadian First Nations artists is notable for its nurturing solidarity, borne of the difficult challenge of transcending the stereotypes and clichés wrongly associated with Indian art. Thus it is fitting that the Eiteljorg Fellowship program is, at its core, a collaboration that actively engages Native people—as artists, consultants, jurists, and writers. It is, as such, a postcolonial endeavor that is helping to create a new kind of museum space for Native fine artists (painters, sculptors, photographers, and artists who work in mixed media, including installations).

A pair of historic paintings clarifies and throws into deep relief what is so significant about the Eiteljorg Fellowship. Around 1938 the Navajo painter Gerald Nailor (TohYah) made an untitled work while a student at the Santa Fe Indian School that shows a shy Navajo family displaying a beautiful rug to a pair of Eastern tourists. The Eastern couple, who are inappropriately dressed for Indian country, are inspecting this example of "ethnic" art, trying to decide if it is the right souvenir of their encounter with "the Primitive." If ever there was any doubt that a picture could speak a thousand words, this one dispels it. The tense, awkward social intercourse that impinged on the commoditization of culture in the reservation period that followed the "closing" of the West is nowhere more transparent. Ostensibly a "quiet" little picture, it generates, in fact, a voluminous if unspoken subtext about the creative process as a form of labor that generates a collectible product—that is, artists are culture workers who must earn a living like the rest of us.[1] Similarly, the Creek-Potawatomi painter Woodrow Crumbo's *Land of Enchantment* (1946) is a social satire on the same theme: a reticent Navajo woman and her daughter show a rug to a family of effete Eastern tourists—caricatures, really, whose presence generates a palpable sense of cultural difference.[2] Absent yet present in both paintings is the money that might change hands.

There is no reason not to acknowledge that money is an inextricable part of the creation, circulation, reception, and institutionalization of art. It would be naïve not to include the exchange of capital in any sophisticated art-historical discourse, and contemporary Native art clearly deserves serious scholarly attention. Try to imagine the flowering of Renaissance art without the patronage of the Medici family or the history of twentieth-century art as we know it without such patrons or dealers as Gertrude Vanderbilt Whitney, Abby Aldrich Rockefeller, Peggy Guggenheim, or Leo Castelli. The National Museum of the American Indian, Smithsonian Institution, has evolved in recent years out of the former Museum of the American Indian, which was established with the formidable collections assembled by the eccentric George Heye. Patronage, however it manifests itself—through a collector, commission, grant, award, or fellowship—is essential to the social context of art. The distinguished art historian Terence Grieder has identified the patron as part of a quartet of the "most important of the varied roles that make up the world of art": artist, patron, critic, and audience.[3] "Patrons and collectors," Grieder writes, "are the life-blood of the art world, providing the money that keeps the whole operation alive."[4] The reason for this is absolutely clear, but needs to be explained, nonetheless. Artists require a staggering variety of materials, which are frequently very expensive, as well as working space and, oftentimes, studio assistants. It is by no means atypical for an artist to need to travel and do research for a particular project. And, like poets, composers, philosophers, and nuclear physicists, artists require lots of unencumbered time in which to doodle, cogitate, reflect, and play. The creative process operates according to its own unpredictable schedule and must be understood both as uninhibited play and as a form of intensely focused "research."

Juried prizes, of course, have been given out in Native American art shows around the country since the 1920s, although until very recently, the criteria for quality and excellence was usually established by non-Indians. The Philbrook Art Center (now Museum) staged annual juried exhibitions of contemporary Native art from 1946 to 1979, with purchase prizes. Since 1983 the Heard Museum in Phoenix has staged seven *Native American Fine Art Invitational* exhibitions, which have played a prominent role in building a sophisticated audience for contemporary Indian art. But since patronage is the "life-blood of the art world," the still-young Eiteljorg Fellowship for Native American Fine Art has set the bar very high. By any measure, a $20,000 honorarium represents a powerful investment in the continued development of an artist. In a time when fellowships and grants for artists are dwindling, the Eiteljorg Fellowship is competitive with virtually all awards for "mainstream" artists, and certainly it is now the gold standard in Native American art. I am emphasizing the financial aspect of the fellowships here because patronage is an essential aspect of the social history of art, and its nurturing stimulation has until recently been the missing ingredient in the evolution of contemporary Native American art.

The first Eiteljorg Fellowship exhibition also set remarkably high standards. Along with the late George Morrison (Chippewa, 1919–2000), who was at that time the "grand old man of Modernist Indian abstraction,"[5] the inaugural exhibition in 1999 featured the artists Lorenzo Clayton (Navajo), Truman Lowe (Ho-Chunk), Marianne Nicolson (Kwakwaka̱'wakw), Rick Rivet (Métis/Dene), and Jaune Quick-to-See Smith (Flathead). I had the privilege of viewing that exhibition, and I can testify that the assembled works signaled the energy, diversity, and integrity of and continued potential for Indian fine arts.[6] In the present fellowship cycle it has been my pleasure be a "silent witness" to the selection process, as three distinguished Native American artists, including one of the inaugural fellows, faced the formidable task of choosing only five artists from the many qualified nominees. The health and maturity of the Native American and First Nations fine arts communities are reflected in the collective achievements of the three jurors themselves. Sara Bates is a Cherokee inter-media artist who works with natural materials. Formerly the director of exhibitions and programs at American Indian Contemporary Arts in San Francisco, she has curated more than thirty exhibitions. Works from her "Honoring" series have been exhibited widely in the United States and in solo shows in France and Italy, and in New Zealand at the World Celebration of Indigenous Art and Culture (1993).[7] Colleen Cutschall (Lakota) is professor and coordinator of visual art at Brandon University in Brandon, Manitoba. Her paintings and installations—including *Voice in the Blood* (1990), *Sister Wolf and Her Moon* (1993), and *House Made of Stars* (1996)—have been seen in numerous solo exhibitions. She is also past president of the Native American Art Studies Association.[8] Truman Lowe, who was represented in the first fellowship exhibition by provocative works on paper and his signature open-work wood sculptures, is professor of art at the University of Wisconsin, Madison, and curator of contemporary art at the National Museum of the American Indian, Smithsonian Institution. He

was a fellow of the National Endowment for the Arts (1994–95) and has had nine solo exhibitions, including *Haga* at the Eiteljorg Museum (1994) and *Neo-Xahnee* at the prestigious John Michael Kohler Arts Center in Sheboygan, Wisconsin (1999).[9]

The five Eiteljorg Fellows for 2001 are no less accomplished, and together their art makes for a pleasing and instructive exhibition with reassuring coherence, despite the diversity of their approaches and subjects. Each produces work that speaks directly to our moment in time. Although all respond in varying degrees to traditional and historic indigenous American art and culture(s), their objects and images would never be confused with so-called "ethnographic art." In fact, the history of modern and contemporary art—both "mainstream" and Native American—is inscribed knowingly in their art. The School of Paris, Abstract Expressionism, Pop art, Minimalism, Conceptual art, post-modernism, and the identity politics of feminist art are reflected, even if subtly, in this exhibition. It is, after all, an exhibition of art on the cusp of the twentieth and twenty-first centuries.

Since our senior artist and fellows are treated at length in the chapters that follow, I will only introduce them briefly here.

Allan Houser, the senior artist who is honored (posthumously) here, was, like George Morrison, a draftsman, painter, sculptor, and printmaker. His work, which managed to fuse emotional intensity, classical calm, cultural history, and modernist aesthetics, was both a commercial and critical success in his lifetime. Among his many admirable characteristics, Houser's ability to "keep it real," when selling out and pandering to a lowbrow audience would have been easy, was notable. That his paintings, and especially his monumental sculpture, were cherished by the Native and non-Native audiences alike is proof positive of its transcendental quality.

Rick Bartow is known for gestural, painterly paintings and prints that examine the transformative and redemptive aspects of art. His is an intensely emotive art that explores the expressionist tradition of figuration, incorporating masklike images and totemic forms. He also carves masks and traditional objects that, like his two-dimensional works, refer back to oral history and to the power of animals and nature. Recently Bartow has added elements of a Japanese syllabary and fragments of German poetry to his graphic art. His almost violent approach to the picture surface has continued to evolve, as befits an artist who has likened the "marks and erasures" of his art to "roots underground or bones beneath flesh."

Joe Feddersen is a painter/photographer/printmaker who has used the computer, collage technique, and a whole host of experimental printing techniques in his art. The resulting images are delicate, thoughtful, and poetic reminders of changing weather, the seasons, and Native textiles and baskets. A quietly insistent geometry, derived from indigenous designs but resonating easily with Modernism, provides the structure of Feddersen's prints, which are created in series. His desire to understand the forms, designs, and structure of baskets encouraged him to make his own, some of which are featured in the 2001 Eiteljorg Fellowship exhibition. Deeply inspired by the stories and

Rick Bartow, *Crow Hop* (fig. 19)

knowledge of his elders and by rock art created by the ancient ones, Feddersen gives artistic life to the idea that the past is always operant in the present.

Teresa Marshall is one clever sculptor. She works with found objects and natural materials, including hides that she prepares herself in the traditional, labor-intensive manner. This is not surprising, since one of her main themes has been a celebration of Native women's work. Biting satire, linguistic games, riffing on popular culture, and elegiac visual songs for extinct tribes are just some of the characteristics of Marshall's sculptures and installations, which often rely on disjunctures in predictable scale. *Eliteke y* (1992), for example, which she exhibited at the National Gallery of Canada, consists of three over–life-size forms cast in concrete that told a powerful story about presence/absence in Canadian and First Nations history. Since then Marshall's art has grown ever more sophisticated and refined as she has investigated different ways of manipulating forms and has invented new processes, including a tobacco variant on papier-mâché.

Shelley Niro established her reputation initially with ironic photographs with a sharp political edge. The visual intertextuality of her photos, such as *The Rebel* (1987), made them consonant with the poststructural notion that every image refers to another. But if these carefully staged photographs, which are sometimes hand-colored, are humorous, they are also "dangerous" in pointing out the overlooked or uncovering the partially hidden. Niro has also made installations involving paintings and/or photographs, which are sometimes decorated with references to Iroquois beadwork. Her films, including *It Starts with a Whisper* (1992, codirected with Anna Gronau) and *Honey Moccasin* (1998), are remarkably polished; I count them among the most poignant First Nations works of art produced at the end of twentieth century.

Susie Silook is a sculptor (and writer) who uses the traditional artistic materials of the Arctic, such as walrus ivory, whale bone and baleen, and seal whiskers. Inspired by the cosmology, oral history, environment, and subsistence patterns of the North, Silook has taken a "male" tradition—ivory carving—and imbued it with a female sensibility. The tenuous balance, graceful arcs, and decorative linearity of her stylized figures beg for the phrase "refined elegance." She manages to imply, with her compositions and her use of open-work form, a sensuous fragility and vulnerability. And yet, a strong, even mythic female presence pervades her sculptures. Silook's figures seem to fly, float, and swim through an unseen but palpable space that they generate with their own quiet dynamism. For a Euro-American audience, some of her sculptures will have a hieratic quality associated with religious art, and even viewers unfamiliar with the conventions of Arctic art will see at once Silook's profound mastery of her materials and techniques.

Collectively, the Eiteljorg Fellows for 2001 have taken note of Native media, designs, forms, and stories and the painful postcontact history of Indian-White relations. But it is a tricky business, I fear, to track and trace what is "authentic" or "aboriginal" about contemporary art made by Native American or First Nations artists, including the five highly talented artists exhibited here. If this is all we look for or recognize, their humanity is diminished and the resonant hum of their art is hushed. Sometimes aesthetic politics are front and center in these works of art, but not always by any means. If any one thing is constant in the works gathered in this second Eiteljorg Fellowship exhibition, it is a sense of aesthetic resolution, which I associate with artistic maturity and integrity.

Notes

1. See W. Jackson Rushing, "Modern By Tradition," in Bruce Bernstein and W. Jackson Rushing, *Modern By Tradition: American Indian Painting in the Studio Style* (Santa Fe: Museum of New Mexico Press, 1995), p. 54 and pl. 44.

2. Crumbo's *Land of Enchantment* is reproduced in Edwin L. Wade, ed., *The Arts of the North American Indian* (New York: Hudson Hills Press in Association with Philbrook Art Center, 1986), pl. 202.

3. Terence Grieder, *Artist and Audience* (New York: Brown and Benchmark, 1996), 18.

4. Ibid., 26.

5. W. Jackson Rushing, "Contested Ground," *New Art Examiner* 19 (November 1991), 26–27.

6. See Bruce Bernstein et al., *Contemporary Masters: The Eiteljorg Fellowship for Native American Fine Art*, vol. 1 (Indianapolis: Eiteljorg Museum of American Indians and Western Art, 1999).

7. See Sara Bates, "Honoring," in W. Jackson Rushing, ed., *Native American Art in the Twentieth Century* (London: Routledge, 1999), 196–204; and Jennifer Complo, "Sara Bates," in *St. James Guide to Native North American Artists* (New York: St. James Press, 1998), 47–50.

8. See Colleen Cutschall, "The Seen and the Unseen Form the Narrative," in Janet Catherine Berlo, ed., *Plains Indian Drawings 1865–1935: Pages from a Visual History* (New York: Harry N. Abrams, 1996), 64–65; Colleen Cutschall, "Garden of the Evening Star," in Rushing, *Native American Art*, 189–95; and Vesta Giles, "Colleen Cutschall," in *St. James Guide to Native North American Artists*, 135–37.

9. See Jennifer Complo, "Truman Lowe," in *St. James Guide to Native North American Artists*, 338–40; Diana Nemiroff interview with Truman Lowe in Diana Nemiroff, Robert Houle, and Charlotte Townsend Gault, *Land, Spirit, Power: First Nations at the National Gallery of Canada* (Ottawa: National Gallery of Canada, 1992), 182–89; Leslie Schwartz Burgevin and Kay WalkingStick, *Haga*, exh. cat. (Indianapolis: Eiteljorg Museum of American Indians and Western Art, 1994); and Hayward Allen, *Truman Lowe: Streams*, exh. cat. (La Crosse: University of Wisconsin-La Crosse, 1991).

AFTER
THE
STORM

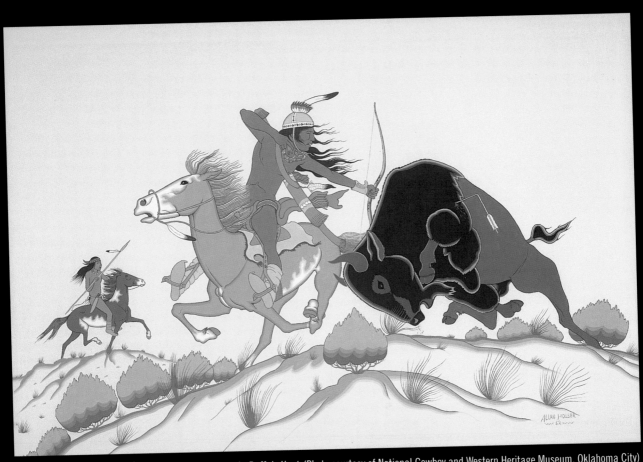

1. *Buffalo Hunt.* (Photo courtesy of National Cowboy and Western Heritage Museum, Oklahoma City)

Allan Houser: American Hero

Chiricahua Apache

W. Jackson Rushing III

History will show that at the beginning of the twenty-first century, the Eiteljorg Fellowship Committee has elected to honor the lifetime achievement in art of the late Allan Houser (1914–1994).[1] The criteria on which the curatorial decision was made to celebrate his art during the second biennial Eiteljorg Fellowship exhibition included the aesthetic quality and the breadth and depth of his work, as well as its profoundly positive impact on younger Native American artists. Houser made inspired works of art in several media—drawing, painting, and printmaking, as well as sculptures in steel, bone, wood, metal, and bronze—in seven decades from the 1930s to the 1990s. Houser was simultaneously a regional, national, and international artist, and his work is intimately associated with the American Southwest from which he sprang. Even so, in his lifetime he was awarded a Guggenheim Fellowship (1949), Les Palmes Académique from the French government (1954), and the National Medal of Arts (1992). His paintings and sculptures are in the permanent collections of numerous prestigious American museums, and in the last decade of his life, major exhibitions of Houser's art were staged in Berlin, Paris, Vienna, and Tokyo.[2]

Intensely proud that he was a Chiricahua Apache Indian, grandson of the famous chief Mangas Colorados, Houser was a sterling role model for younger artists. A noted teacher, he gave his time, talent, expertise, and resources generously and charitably in an effort to educate, nurture, and support his students and younger peers in the world of Native American art. Occasionally in the history of art we find an artist for whom the same adjectives will suffice to describe both his style and his personal character. Houser and his art are a case in point, and we can speak productively of both as quiet but sturdy and dignified; elemental yet sophisticated; humble and monumental; reserved and tenacious; and autochthonous but decidedly cosmopolitan. Other kinds of diversity can be identified in

Houser's art as well, given that from one period to the next his work could be described as narrative, iconic, or abstract, depending on what issues of subject matter, problems of form, or technique he was seeking to investigate and resolve. What Houser offered his students and other Native artists was a "quiet" and highly personal cultural politics, in which he subtly addressed racism against American Indians and the historic and violent persecution of Native peoples. He accomplished this by being a modest but self-respecting "fine artist," whose beautiful objects embodied the pride, honor, and tenacity of Native Americans.

Like George Morrison (1919–2000), the Anishinabe painter and sculptor who was honored for his lifetime achievement in the first biennial Eiteljorg Fellowship, Houser was a "restless" artist who was constantly experimenting with different materials and techniques and for whom the invention of "significant form" was indivisible from the content of a work of art.[3] And like Morrison, he, too, came of artistic age after World War II and transformed the audience's assumptions and expectations about "Indian" art by refusing to accept any limits other than his own. Both of them made their mark, in part, because they had the courage to embrace and manipulate for their own ends selected aspects of Euro-American modernism. Like so many modern artists, Houser and Morrison were fascinated with tribal and ancient art, and both artists made sculptural forms, often abstract or abstracting, that were meant to evoke spiritual essence. And the land that nourished their respective Native nations figured in Morrison's and Houser's art in a manner both subtle and direct. Houser's Southwestern lands—Oklahoma, New Mexico, Arizona, and Colorado—are oftentimes the unseen conceptual ground of his sculptures, even as they appear in reductive form in his two-dimensional art.

Houser grew up on his parents' farm outside Apache, Oklahoma, and he began his studies in art
in 1934 at the legendary "Studio," which Dorothy Dunn had established at the Santa Fe Indian
School. He went there with a desire to learn cartooning and life drawing, with an eye toward making
Western paintings in the style of Charles M. Russell. What he learned instead was the flat style of
"traditional Indian painting," which emerged more or less simultaneously in Oklahoma and Santa Fe
in the early years of the twentieth century and which Dunn had codified and institutionalized in her
curriculum at the Studio. Amazingly, when Houser was a student at the Studio in the 1930s, he was
part of a coterie of young artists who went on to dominate Native American painting in the decades
that followed: Harrison Begay, Joe Herrera, Oscar Howe, Gerald Nailor, Andrew Tsinhnahjinnie, and
Pablita Velarde. Seldom has such a concentration of young talent been found in a single art school at
any one time. After he left the Studio, Houser briefly operated a professional studio with Nailor in
Santa Fe in the late 1930s and then worked in Los Angeles during World War II. He returned to farm
in Oklahoma briefly and from 1951 to 1962 was teacher and artist-in-residence at the Inter-Mountain
Indian School in Brigham City, Utah. The Studio, which had continued on under the leadership of
the painter Geronima Cruz Montoya (Jemez Pueblo) after Dunn's departure in 1936, was superceded
in 1962 by the Institute of American Indian Arts, and Houser was one of its preeminent founding fac-
ulty members. He retired as head of its sculpture department in 1975 to devote himself fully to his
own practice as an artist. Although he was known internationally from the 1960s onward for his sculp-
ture, Houser continued to make paintings, drawings, and prints that are admirable in and of them-
selves but that also shed light on his work as a sculptor.

In Houser's archives there are hundreds of unpublished drawings of singers, drummers, shepherds, warriors, mothers, and children in arid Southwestern lands.[4] While some are "finished" drawings, other are studies that reveal the artist working out problems of form, color, space, and plasticity. Indeed, one is struck by how sculptural his two-dimensional figures are and how the masses of their bodies imply the tectonic forms of the earth from which they sprang. Autochthonous and often monumental, these Native figures do not seem to occupy the mountains and deserts of the Southwest so much as they are contiguous with them. In their quiet grandeur and in the graphic modeling of their forms, they reflect Houser's interest in the art of the modern Mexican artists Diego Rivera and Francisco Zuniga. But along with the figures are drawings of, and for, *abstract* sculptures. Here, too, there are polished works on paper along with sketchier images that show, for example, the progressive transformation of a sharp-beaked bird into an angular, geometric sign for avian energies. And what a melange of style and subject matter is to be found in these drawings, from mounted riders rendered in "cowboy realism" to studies of tribal sculpture from Africa and elsewhere, along with notations in the artist's hand. Although some of the abstract drawings can be identified with particular sculptures in Houser's oeuvre, many of them cannot, and thus they are not really studies for, but rather are pictures of, unrealized sculptures. Like the British artist Henry Moore, whom Houser admired greatly, he had far more ideas and concepts for sculptures than could ever be worked out in three dimensions. And both of them were notably prolific and decidedly proletarian in their work ethic. Even so, in order to partially satiate an insatiable appetite for sculptural form, both used drawing as a way to "create" more "sculptures" than the logistics of the shop and foundry would allow. That Houser had such a need is remarkable, given that he was an indefatigable sculptor who created hundreds of objects, many of them monumental in scale, over the course of his ambitious career.

Houser made sculptures in wood and stone through the 1950s, but it was only after his return to Santa Fe in 1962 that he began to establish an international reputation as a sculptor. In particular, a series of powerful direct stone carvings, which included such works as *Proud Heritage* (black Tennessee marble, 1976), announced him as a mature artist capable of unifying form, content, and image into a compact and emotionally satisfying whole. Simultaneously archaic and modern, the stony figures of this period often achieve their balance of feeling and form by playing a rusticated surface off against a highly polished one. Houser's biographer, Barbara H. Perlman, noted this aspect of *Proud Heritage*:

> The polished, enormously forceful male Indian face gleams like a newly unearthed gem, framed by the roughly chiseled, broadly cut planes of a heavy cloak. The austere beauty of the masklike countenance is heightened by the harshly textured mass that surmounts the head like a crown or halo worthy of an Aegean priest-king or Byzantine Emperor. . . . The importance of Houser's Apache history is nowhere personified with greater luminosity of character.[5]

In short, in keeping with modernist aesthetic principles, Houser allowed the materials to have a "natural" voice. By calling attention to the texture of his chosen materials, whether it was pine, alabaster, Indiana limestone, slate, or Carrara marble, he allowed the sculpture to be as much about the invention of significant form as it was about a specific individual, memory, or idea. Besides carving

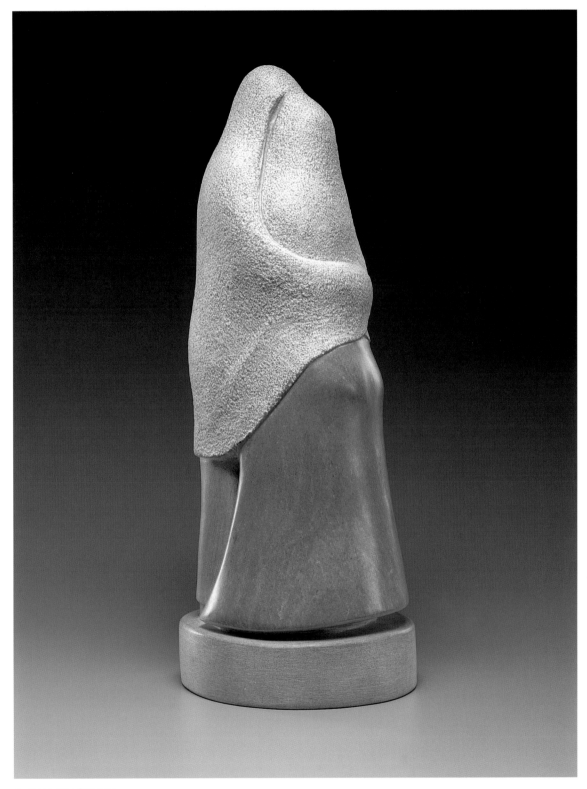

3. *Reservation Romance*

American Hero

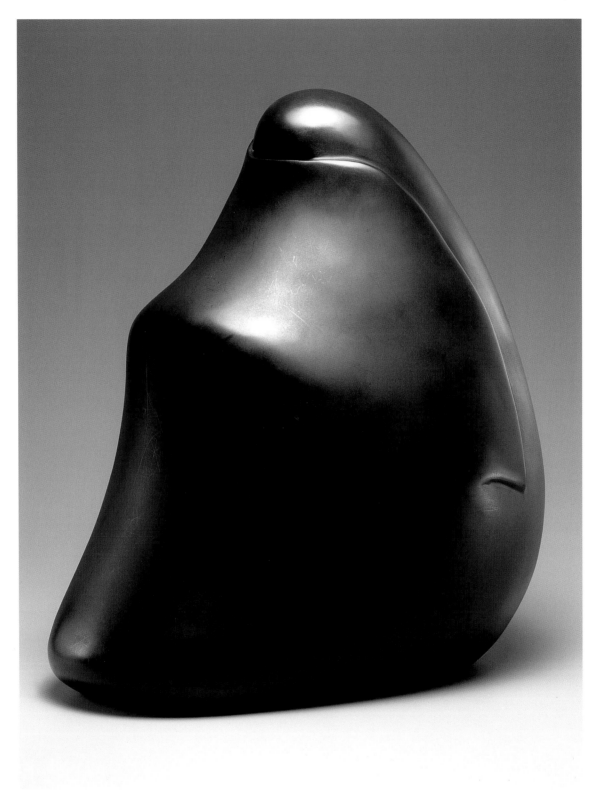

4. *Silent Observer*

Allan Houser

stone—perhaps his strongest suit, whether in figurative or abstract forms—Houser also welded Corten steel and cast numerous additions in bronze.

His *Earth Mother* (fig. 10) is a majestic aboriginal archetype: like classical Greek statuary, her massive form is soft, round, organic, and sensuous. Her spreading lap is wide, stable, and nourishing, and the child she protects appears to sink within the totality of her being. Rising up like a mountain, her body and deeply plastic face are a landscape in and of themselves. To his credit, Houser used the "essentialism" of modern European sculpture (Moore, Constantin Brancusi, Barbara Hepworth) for his own ends, which included locating the essence or indwelling spirit of Southwestern Indian cultures in unique individuals, such as his "earth mother." Neither vanquished nor vanished, she is languid and proud. With her eyes closed in calm, meditative repose, she is the aboriginal equivalent of the modernist thing-in-itself.

Not only did Houser share with Moore a deep, abiding affinity for the theme of the mother and child and a tendency to treat the female form as a metaphorical landscape, but he also moved back and forth between representation and abstraction. In fact, this is a quality that Houser shared with a number of other twentieth-century artists of some renown, including Pablo Picasso, Emil Bisttram, Jackson Pollock, Will Barnet, and Philip Guston. In this exhibition his abstract oeuvre is represented by two bronzes from 1992: *Options II* (fig. 5) and *Migration* (fig. 6). Houser certainly understood his audience's horizon of expectation and provided them with dozens of poignant sculptural images of Native life in the American Southwest, including two also shown here: *Drama on the Plains* (fig. 11) and *Smoke Signal* (fig. 7). But for his own satisfaction as an artist he needed to explore his subjects more conceptually on occasion, which allowed him the freedom to speak more indirectly without a loss of authority. Responding to an inner vision, he investigated the formal language of sculpture while invoking the drama of both history and nature. Reductive yet expansive, the abstract works are more open-ended, and yet they are every bit as poetic and emotive as the figurative pieces. Using centrifugal and centripetal forces in place of charging buffalo or thundering equestrians, Houser's abstract forms are paradoxically dynamic and resolutely still.

Corngrinder (fig. 9), one of the last sculptures Houser made and a most welcome presence in this celebratory presentation of his art, reminds us that the beauty of women—their songs, prayers, and labors—had an enduring place in his paintings, drawings, and sculptures. Solid as a rock, the corngrinder or everywoman is the literal and symbolic foundation of Native society. A full decade before the women's movement in the United States began calling for a reconsideration of the place of women in our society, Houser made pictures and sculptures of Indian women that testified to their quiet power and triumphant resilience. Not only do Houser's robust women survive to enculturate the next generation of Native children, but, to borrow from the Navajo, they "walk in beauty." So, too, Allan Houser walked in beauty: a soft-spoken, rustic man in a French beret, who charmed museum audiences with his stories and flute playing. In an era marked by irony, hype, and glitz, his earnestness and

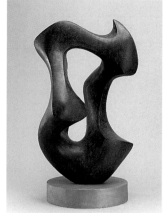

steadfast devotion to craft and community were not only refreshing but inspiring and restorative. In the time of the antihero, he was a real hero, and not just to Native Americans, but to all people who respect resolve in the face of adversity. Houser's nurturing, grandfatherly presence is sorely missed in the world of art, but thankfully, the humanistic values that he cherished and which we all need now more than ever, live on in his art.

Notes

1. On Houser, see Barbara H. Perlman, *Allan Houser* (Santa Fe: Glenn Green Galleries, 1987); W. Jackson Rushing, "Essence and Existence in Allan Houser's Modernism," in *The Studio of Allan Houser*, exh. cat. (Santa Fe: Wheelwright Museum of the American Indian, 1996), 7–16; Gerhard and Gisela Hoffmann, "Allan Houser, " in *St. James Guide to Native North American Artists* (New York: St. James Press, 1998), 239–42; Tryntje Van Ness Seymour, *When the Rainbow Touches Down* (Phoenix: The Heard Museum, 1998), 47–52; and Guy and Doris Monthan, *Art and Indian Individualists: The Art of Seventeen Southwestern Artists and Craftsmen* (Flagstaff: Northland Press, 1975). On Dorothy Dunn and the Studio, see Bruce Bernstein and W. Jackson Rushing, *Modern by Tradition* (Santa Fe: Museum of New Mexico Press, 1995).

2. See Rushing, "Essence and Existence," 8.

3. When I had the opportunity to conduct a casual interview with Houser one summer evening during Indian Market in Santa Fe in 1982, he spoke at length about "studio stuff," including the varying resistance of different sculptural materials and the machinery and logistics of a sculptor's studio. He wanted younger artists, he explained, to understand about forms, equipment, and processes. On George Morrison, see David W. Penney, "George Morrison," in *The Eiteljorg Fellowship for Native American Fine Art*, vol. 1 (Indianapolis: Eiteljorg Museum of American Indians and Western Art, 1999), 16–25; George Morrison, *Turning the Feather Around: My Life in Art* (St. Paul: Minnesota Historical Society Press, 1998); and Katherine Van Tassell et al., *Standing in Northern Lights: George Morrison, A Retrospective* (St. Paul: Minnesota Museum of Art, 1990).

4. I am especially grateful to Nelson Foss, the archivist for the Houser estate, for his assistance with my research.

5. Perlman, *Allan Houser*, 163.

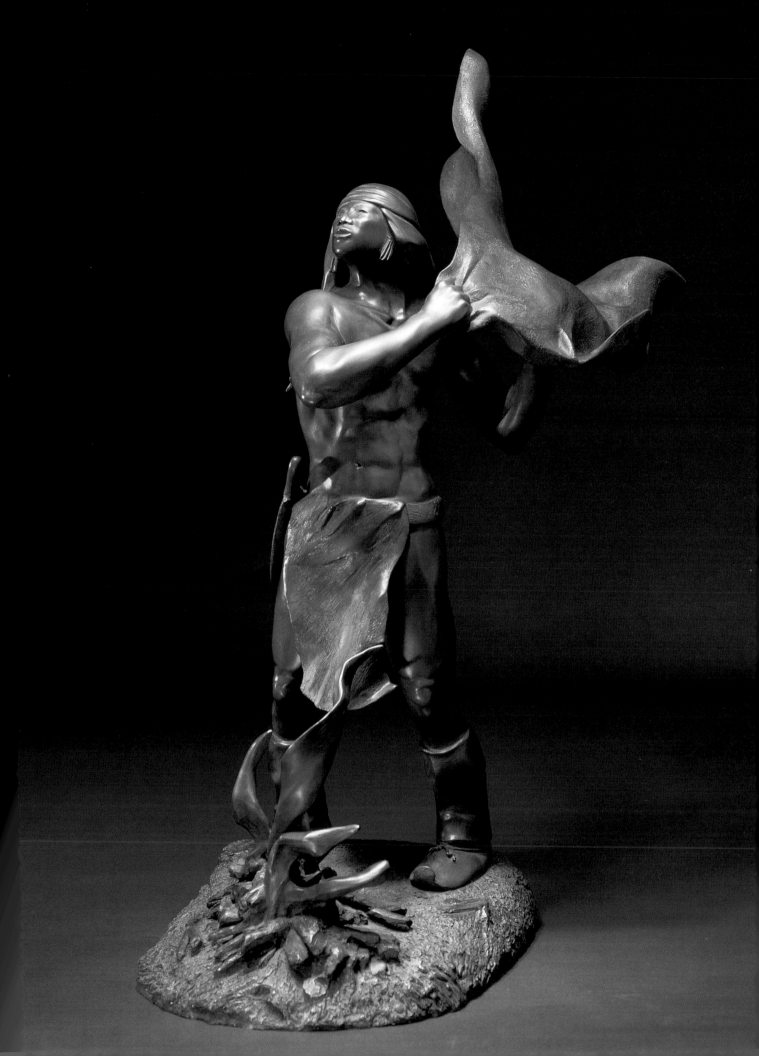

8. *Apache Ga'an Dancer*. (Photo by James Hart Photography, Santa Fe)

Allan Houser

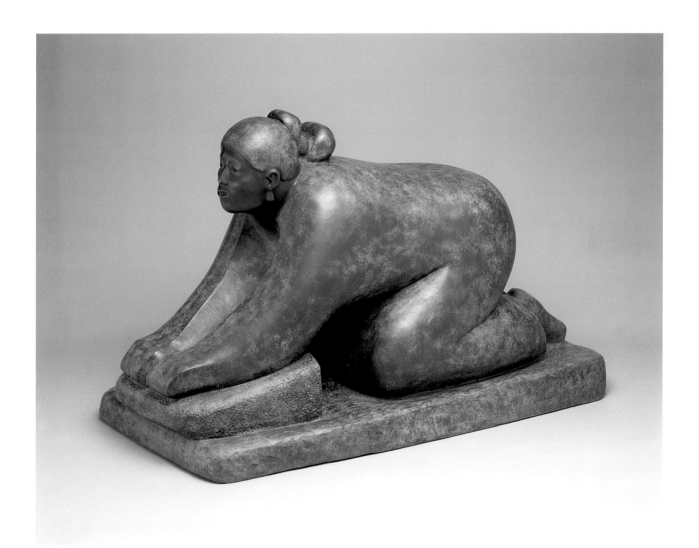

9. *Corngrinder*

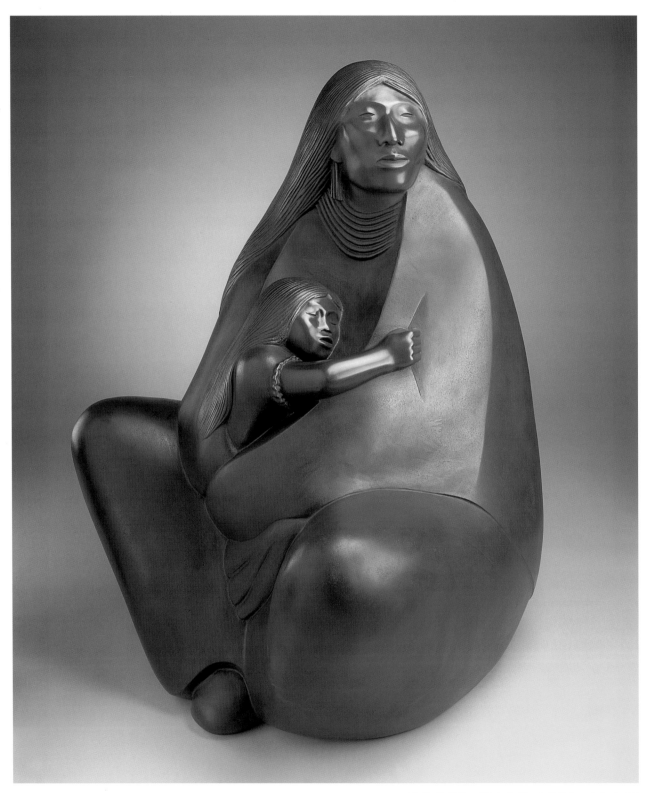

10. *Earth Mother.* (Photo by Wendy McEahearn, Santa Fe)

Allan Houser

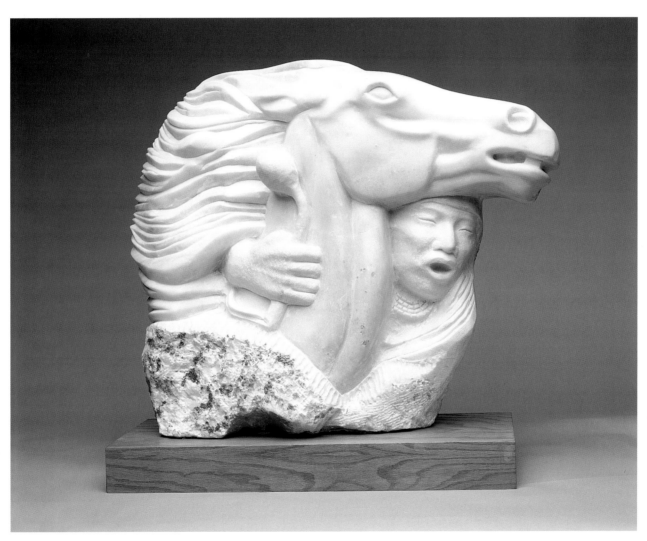

11. *Drama on the Plains.* (Photo courtesy of Buffalo Bill Historical Center, Cody, Wyo.)

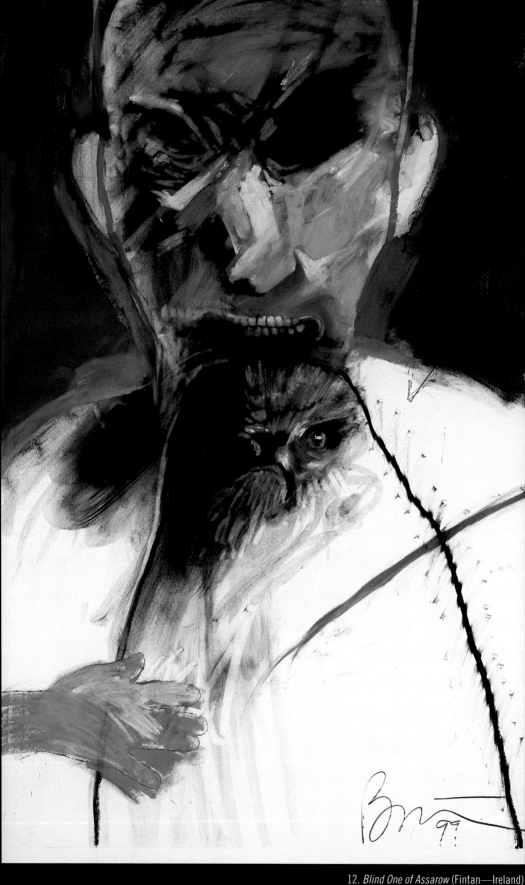

12. *Blind One of Assarow* (Fintan—Ireland)

Rick Bartow: Transforming Images
Yurok/Mad River Band

Carol Podedworny

Rick Bartow, who was born in 1946 in Newport, Oregon, received a Bachelor of Arts degree in art education in 1969 from Western Oregon State College. Since he began exhibiting professionally in the mid 1980s, his work has appeared in several significant exhibitions, including the Heard Museum's *Shared Visions* (1991) and the Native American art group Atlatl's *Submuloc Show/Columbus Wohs* (1992). Bartow is an artist, teacher, and musician who currently lives and works on ancestral land in Oregon.

Bartow works in both two and three dimensions. He draws gestural and expressive works on paper in pastel, graphite, and charcoal. The large areas of color or hue are also gesturally applied in that he reworks and refines them through repeated erasure, smudging, and manipulation. Bartow is "all over" his drawings, not only as an artist but also as a feeling, thinking human being. The images are full of power and passion, and the drawings seduce by virtue of their beauty.

As a sculptor, Bartow uses both natural and manmade, found materials. Most of the sculptures are small in size and are often reminiscent of hand-held fetishes, icons, or talismans. What they have in common is a sense of individuality, of character particular to the being (animal or human) that they seem to portray. Perhaps it is because they all have faces—doorways to the figures' souls—that the sculptures seem animate, even human. This is not to say that the works are strictly representational, but rather, like Bartow's drawings, the sculptural works are full of expressive potential. Eyes gaze beyond the moment, and figures are fashioned of shapes, sizes, and materials that can only elicit subjective associations of "bodiness." As objects one might hold in one's hands, Bartow's sculptures read as protectors.

Personal, social, artistic, and theoretical sources have informed the art Bartow has created as a sculptor and draftsman. It is important to Bartow's work that he spent eighteen months in the war in Vietnam. Moreover, it is significant for the artist that he lives on Indian land and that he has a dual heritage: both Native (Yurok) and non-Native. Subsequently, Bartow's passionate art seems imbued with beauty and history. The history from which he works is informed by his life experience, his ancestral links, and his apparently ceaseless and uncanny ability to fathom the ache of human frailty. Bartow's history—like his drawings and sculptures—is not based entirely on actual events and people—though real associations do exist. An important element in the creation of Bartow's history is storytelling. Telling stories is an old activity, common to the Native American side of his ancestry, that is synonymous with creating from fact, from myth, and from personal sensibilities. This kind of history is true and pure. It reveals its biases through genuineness and passion. It reveals its truths through the exposure of emotion in what is often perceived to be fact. Historical storytelling is the vehicle through which Bartow can tell tales of his culture in a manner that reveals its heartbeat.

Bartow is also a social activist. His drawings often picture human struggle, whether that be in a physical, mental, or spiritual battle. The undifferentiated grounds—containing only color and gesture—confirm their presence as the location of spiritual insight and endeavor. The drawings *Biting Through 3* (fig. 25), *28 + 13 Selbst* (fig. 26), and *Gabriel's Struggle* (fig. 27) are examples of the artist's conception of struggles conducted in the spheres of physical, mental, and spiritual anguish, respectively. They are fed by the passing of his wife. Indeed, death—facing it, outwitting it—has been a prevalent theme in Bartow's work. *Gabriel's Struggle* seems a "dance with death," whereas *Brush with Death* (fig. 15) and *Aggie II* (fig. 16) call up varied responses to death. The first seems playful in its punning (an artist's brush forms the central figural component of the work), the second painful. Since the figure in *Aggie II* has only one breast, it is worth noting that Bartow's wife succumbed to breast cancer.

Many of the works that Bartow has created over the years have been informed by his own experience. He has brought to the picture surface images and expressions of his indigenous culture, his experience of war, his battle with alcoholism, and his relationships with mentors, friends, and family. Whereas many of these themes are inherently fueled by passionate associations, he has also brought to the description of his Native American heritage a similarly passionate embrace. Works such as *Fox Spirit* (fig. 13), *Cultural Hero* (fig. 14 a, b), *Coyote Mask* (fig. 20), and *Crow Hop* (fig. 19) present cultural associations with animals and the land that recall origin myths, but do so with an eclectic understanding of contemporary culture. These elements in Bartow's development as an artist have no doubt influenced the singling out of his practice as worthy of an Eiteljorg Fellowship for Native American Fine Art. These elements will also ensure that his art work is remembered by future generations.

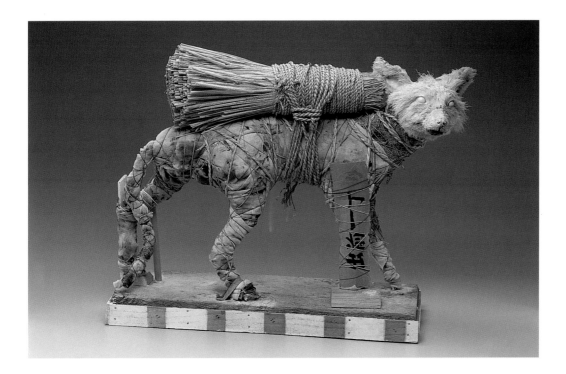

Bartow's artistic sources are generated from both within and without the Native American art community. He finds relevance to his development in the work of Marc Chagall as much as in that of Joe Feddersen. Chagall offers Bartow an example of where to find authenticity in his own life, whereas Feddersen is a significant source for Bartow's conception of animal imagery as an expression of indigenous heritage. One way in which this eclecticism is made manifest is in Bartow's "homage" works. Drawings such as *After Vermeer Girl in Red Hat* (fig. 17) and *After Vermeer Girl with Pearl Earring* (fig. 18) acknowledge fellow artists whose work has inspired or influenced him. In each instance, there is a passage in the work that recalls the individual named in the work's title. Bartow has produced work "for" contemporary Native American artists such as Lillian Pitt, Harry Fonseca, and Joe David, among several others.[1]

Beyond references to specific artists, Bartow extends his investigations in much broader terms as well. On the one hand, the artist searches his own Yurok roots, but he has also found inspiration in the designs of Maori artist John Ford and in the languages of other cultures—German, Japanese, and Maori among them. Sculptures such as *Fox Spirit* (fig. 13) and *Cultural Hero* (fig. 14 a, b) contain texts in Japanese that may have literal significance, but which are utilized also purely for their aesthetic beauty. While the sources in Bartow's work are eclectic, the intention is "authentic" Bartow rather than pan-Indian. Such cross-fertilization is essential to Bartow, who works in an art community and within a social structure that has questioned "authenticity" in Native American craft and art

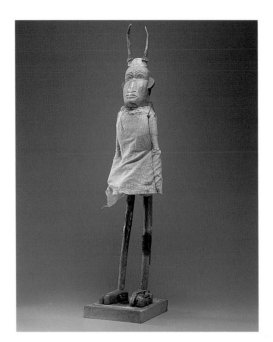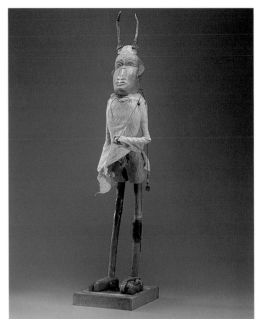

since at least the 1930s. As the artist has stated, "I can't evade the fact that I'm white, and I can't evade the fact that I'm Indian. How can you be anything but what you are?"[2]

One of the themes to which Bartow has repeatedly returned is that of transformation. While the transformation of humans into animals and back again is an essential element of traditional Northwest Coast indigenous art, Bartow sees the relevance of this tradition to his work more indirectly than has been reported. First of all, as Bartow notes, "For me, who has never been in a reservation situation, it would be foolish to try to do tribal art."[3] Moreover, the artist sees wider implications in a contemporary context for this kind of metaphor. Without denying a known indigenous source for the transformation thematic, Bartow imagines works such as *Crow Hop* (fig. 19) and *Coyote Mask* (fig. 20), for instance, to be cognizant of a Native American belief in the importance of animal and human interrelatedness. The artist removes himself from a direct interpretation of a historical source inspiration, however. As he noted in a recent interview,

> The transformation is not so much a transformation, but a literal representation that we are them [animals], they are us, because we're in the same cesspool here right now, we've all got the same problems Things have happened to me at the sweat lodge that indicate certain things to me that we're all in it together. And so I don't see the work as transformational as much as being literal.[4]

Yet transformation—as a means of "making considerable change in [one's] outward appearance, character, disposition, etc."—seems a fitting analogy for Bartow (an artist of immense and charitable capacity) to borrow, adapt, and make his own. The shifts and changes required in the persona and physical form of the being that is transformed to revelation? perception? renewal? extend Bartow's imagery from personal stories to cultural history. Transformation seems an appropriate metaphor through which he might describe the capacity of the human spirit to gain control and seek balance and empathy through symbiosis. Bartow has asked, "What can I draw that is going to make a

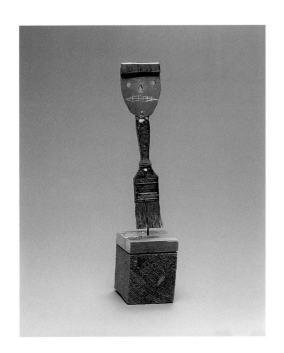
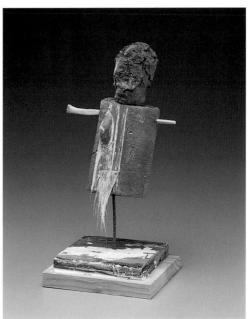

15. *Brush with Death*

16. *Aggie II*

difference?"⁵ Works that cue tradition while expressing a present cultural currency make that difference. What is important about heritage in this context is its capacity for change amidst persistence.

In the arena of contemporary North American indigenous art, Rick Bartow is part of a generation that has come of age during—and been responsible for—the creation of an expanded art community. Working in a community wherein issues of access and representation, and diversity and exclusion were only recently exempt from its vocabulary, he and his colleagues stand at a particularly significant juncture in the evolution of American art history. The generation immediately preceding Bartow's operated in an arts community that, for the most part, viewed Native American art as artifact, craft, or collectible. The activity and voice of Bartow's generation has enabled the discussion of their work to take place in a framework defined by the so-called fine art world. The repercussions of this shift have been both good (access, representation, empowerment) and bad (assimilation, ghettoization), and continue to ripple throughout the arts community. Bartow's contribution to the world of Native American art—which today crosses into that of the mainstream—is an ability to express and define indigenous cultural veracity with power and currency.

Notes

1. Interview with Charles Froelick of Froelick Adelhart Gallery, Portland, Ore., 2000.

2. Larry Abbott, "Rick Bartow," in *A Time of Vision: Larry Abbott Interviews* (November 2000),
 at http://www.britesites.com/native_artist_interviews/rbartow.

3. Dubin, Margaret, "Talking: painter/sculptor, Rick Bartow," *Indian Artist*, Winter 1999: 40.

4. Abbott, *A Time of Vision*, 3.

5. Ibid, 8.

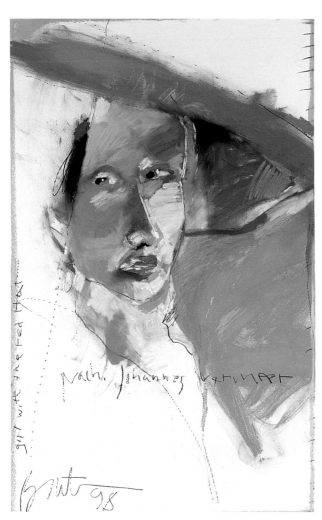

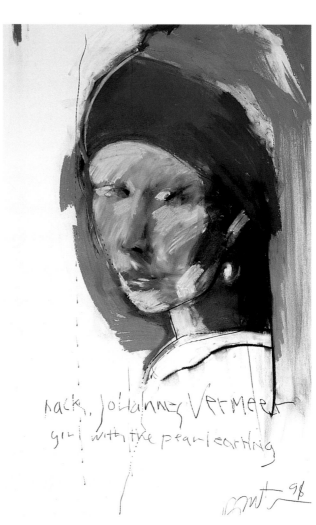

17. *After Vermeer Girl in Red Hat*

18. *After Vermeer Girl with Pearl Earring*

Rick Bartow

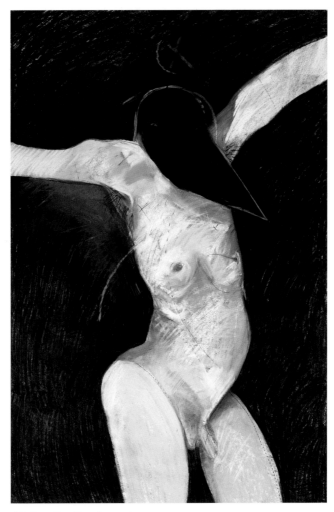

19. *Crow Hop.* (See also p. xv)

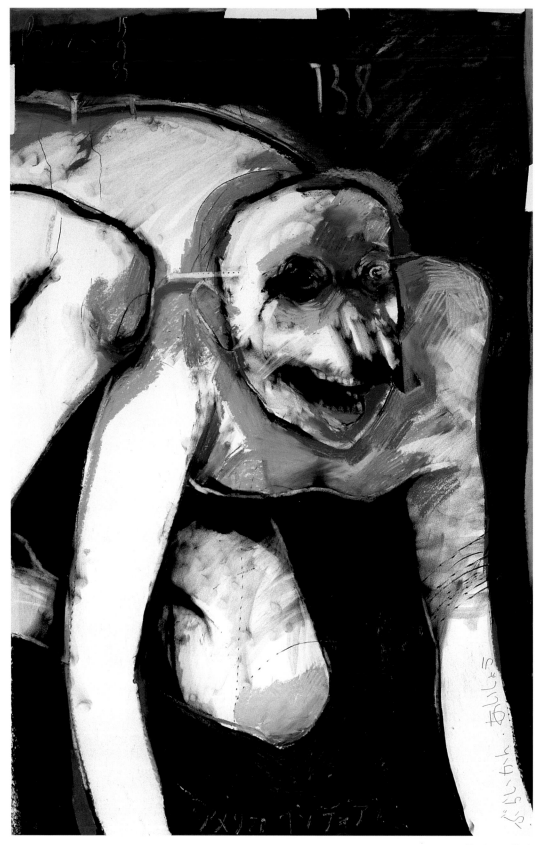

20. *Coyote Mask*

Rick Bartow

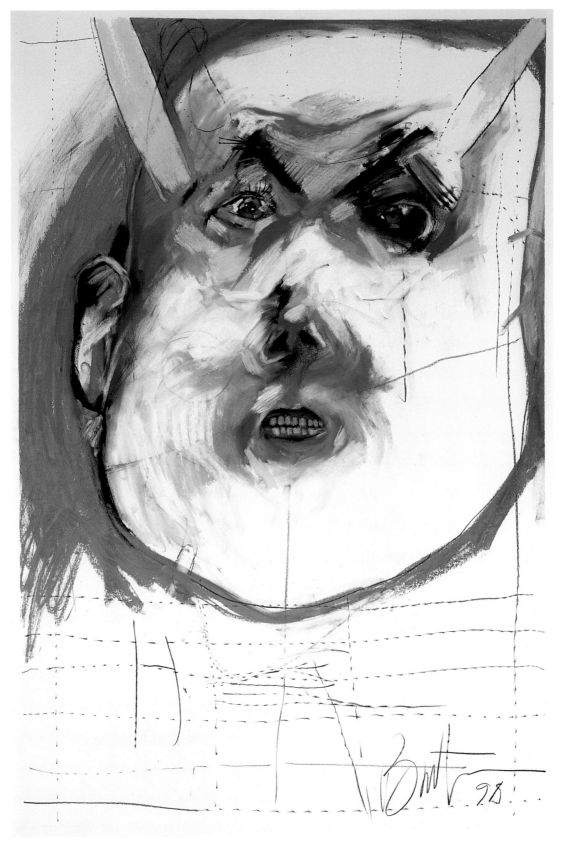

21. *Now Hanniya*

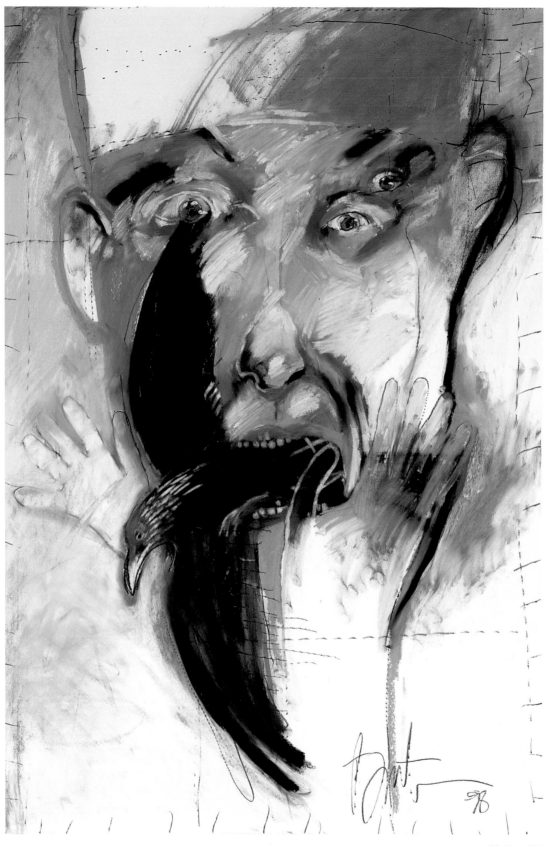

22. *Crow Talk*

Rick Bartow

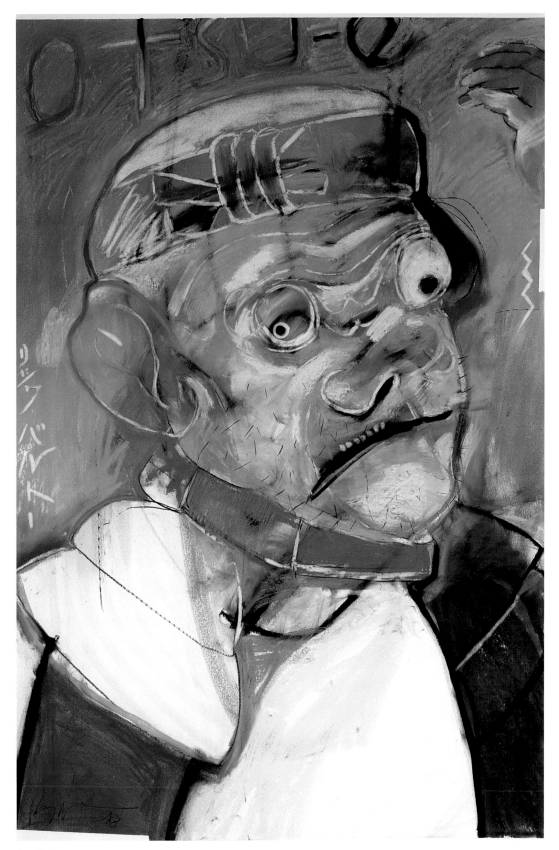

23. *Big Otsue*

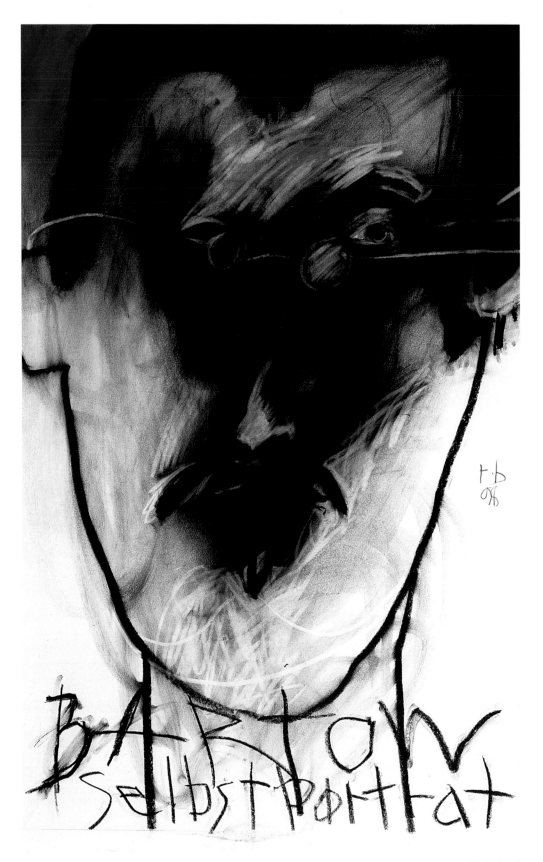

24. *Selbst II*

Rick Bartow

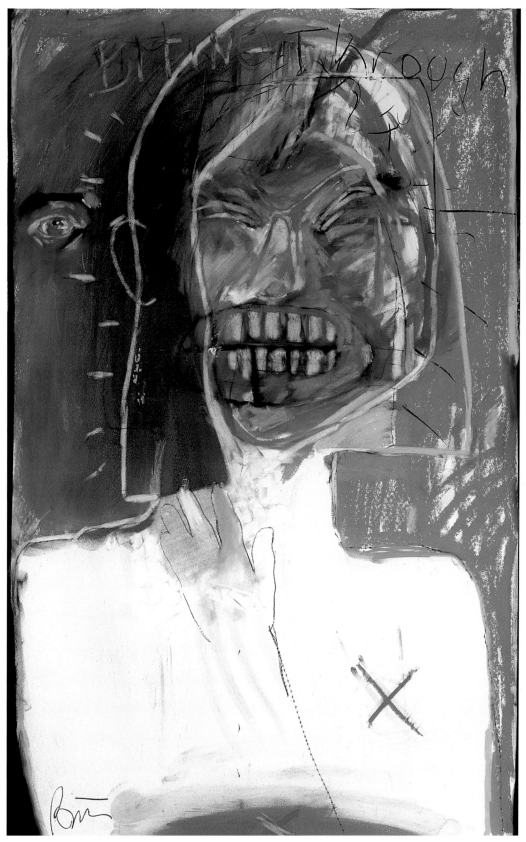

25. *Biting Through 3*

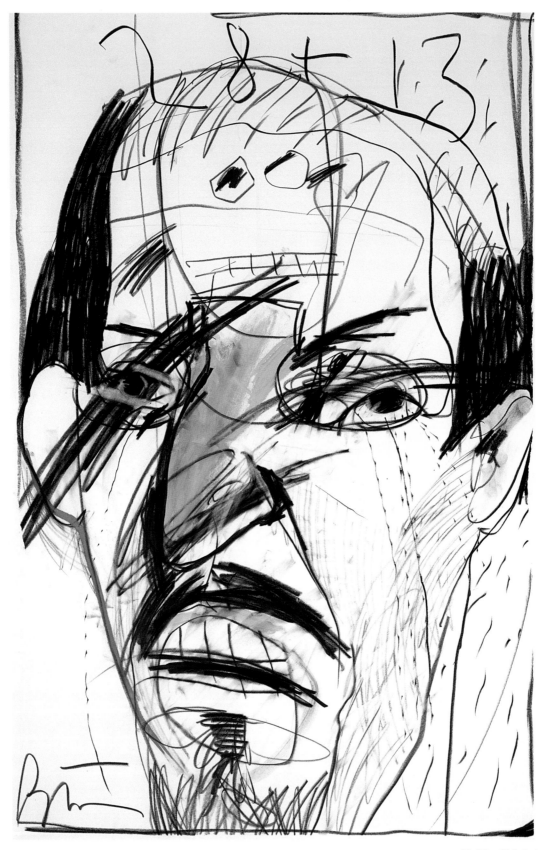

26. *28 + 13 Selbst*

Rick Bartow

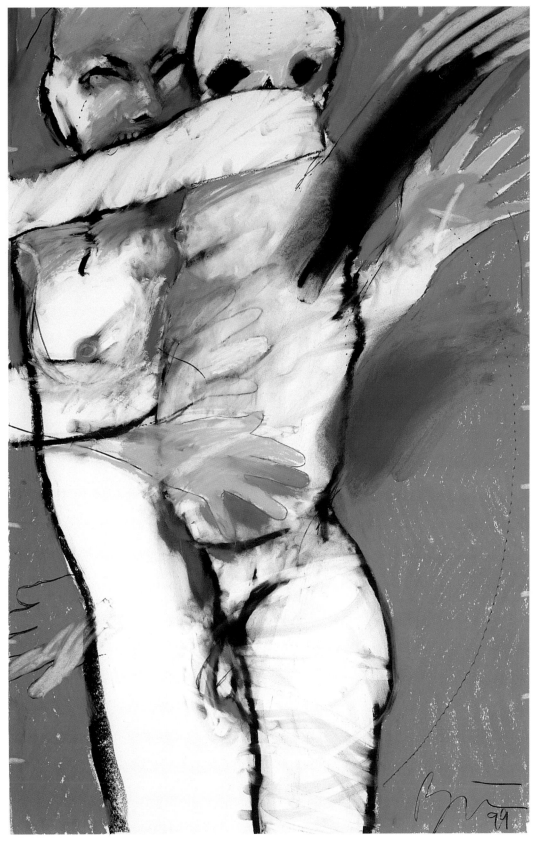

27. *Gabriel's Struggle*

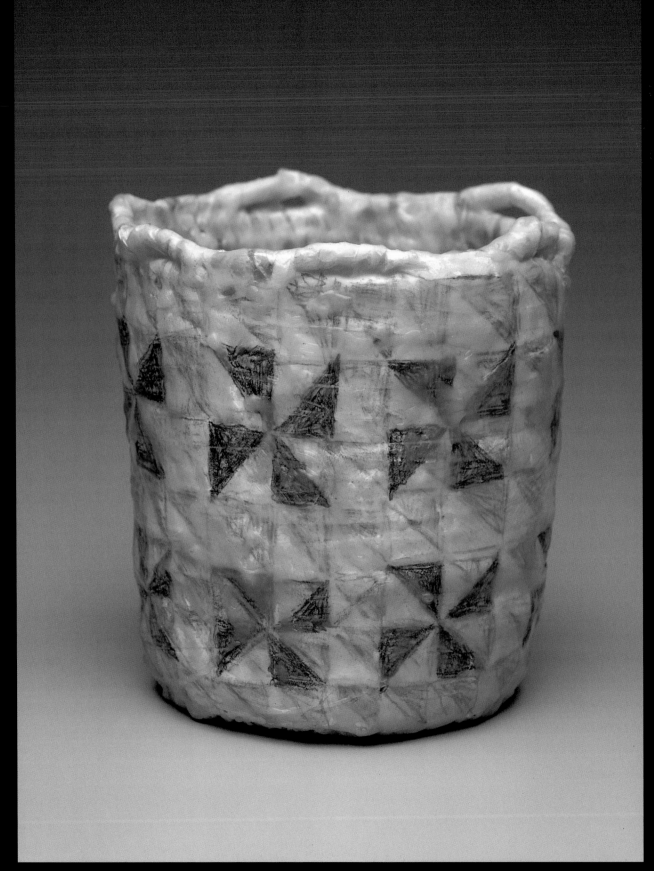

28. *Pin Wheel*

Joe Feddersen: Sacred Geometry

Colville Confederated Tribes

W. Jackson Rushing III

Joe Feddersen's artistry has been evolving surely and steadily for almost twenty years now, and his selection as an Eiteljorg Fellow in Native American Fine Art strikes me as both logical and natural. The effect of his "intimate, reflective art," the critic Abby Wasserman wrote some fifteen years ago, "is both familiar and hauntingly mysterious,"[1] and Feddersen conjures this complex range of emotional response in a variety of media. He is or has been, at various times, a painter, photographer, and maker of masks, baskets, and mixed-media constructions involving graphic arts and such natural materials as deer antlers. But his critical reputation, which is by now well established, is based on richly layered, experimental prints.

Born in Washington State in 1953 of Okanogan/Colville heritage, Feddersen earned his B.F.A. in printmaking at the University of Washington (1983) and his M.F.A. at the University of Wisconsin, Madison (1989). Since 1989 he has been an art instructor at Evergreen State College in Olympia. In addition to an impressive exhibition history, Feddersen has also been active as an essayist, curator, consultant, and member of the Colville Confederated Tribal Arts and Humanities Board.[2] He has had solo exhibitions in several venues, including the Sacred Circle Gallery in Seattle (1984, 1985), the C. N. Gorman Museum at the University of California, Davis (1986), and American Indian Contemporary Arts in San Francisco (1988). He and the Native poet and visual artist Elizabeth Woody were featured in an important two-person exhibition, *Archives*, at the Tula Foundation in Atlanta (1994).[3] Even a short list of the historic group exhibitions Feddersen has shown in would be quite long, but

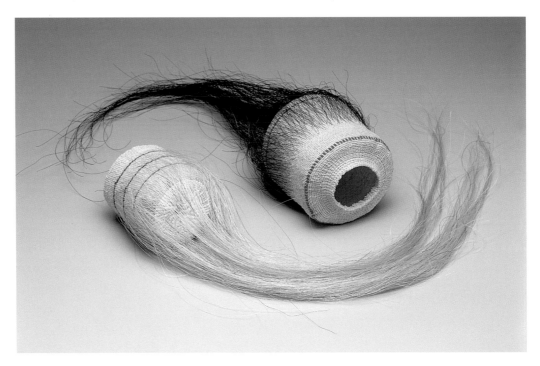

several warrant citation here: *No Beads, No Trinkets*, Palais des Nations, Geneva (1984); *Signale indianischer Künstler*, Gallerie Akmak, Berlin (1985); *New Directions/Northwest*, Portland Art Museum (1986–88); *3rd Biennial Native American Fine Art Invitational*, Heard Museum, Phoenix (1987); *Our Land/Ourselves*, University Art Gallery, SUNY Albany (1991); *The Submuloc Show/Columbus Wohs*, organized by Atlatl, a national Native arts service organization (1992); and *La Jeune Gravure Contemporaine*, Salle de Fête de la Maire du Vieme, Paris (1995). In addition, his art has been exhibited frequently in New York and Chicago, was seen throughout Latin America in a traveling exhibition organized by the USIA Arts American program beginning in 1993, and was published in the seminal *Portfolio: Eleven Indian Artists* (San Francisco: American Indian Contemporary Arts, 1986).

A series of photograph/collage self portraits in the early 1980s established artistic identity as linked to the environment as one of Feddersen's leitmotifs. In *Self Portrait* (1983), his split image, with its destabilizing shifts in scale, is amended with shells, stars, dice, thread, and string, hinting already at his penchant for exploring with mixed media. When this work was published in Lucy Lippard's *Mixed Blessings* (1990), she remarked on his long-standing "concern with human relationships to the environment or what the artist himself describes as 'the delicate balance between self and external force.'"[4] In this series, Feddersen often split his own face and presented the two halves as unmirrored images, as if the two parts did not quite fit together or as if they signaled different states of being. For Lippard, Feddersen appeared to be "straddling fantasy and reality, two worlds."[5] An alternative reading proposes that the various components of an artist's persona—indeed, anyone's persona—do not necessarily fit together smoothly like the parts of a commercially manufactured jigsaw puzzle, or that reality is continually shot through with fantastic bits of unreality.

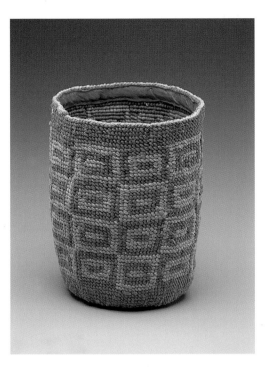

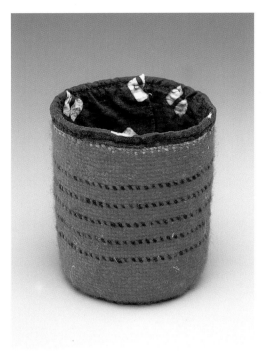

Feddersen's reputation as a serious and sophisticated artist began to reach a critical mass when lithographs from his "Rainscape" series were exhibited in the 3rd Biennial Native American Fine Art Invitational at the Heard Museum in Phoenix in 1988. Referring to such works as *Rainscape* (1987) and *Beyond the Clouds* (1987), he wrote in the catalog:

> My prints and mixed media work explore personal perceptions of my surroundings. . . . Earlier prints become the departure for new work. They incorporate printing techniques and the addition of staples, pins, mirrors, oil pastels and acrylics to achieve a rich surface quality while retaining the luminosity of previous layers.[6]

The reception of the "Rainscape" series, by both artists and critics alike, was extremely positive. The distinguished Native artist and curator Jaune Quick-to-See Smith (Flathead), herself an Eiteljorg Fellow in 1999, wrote of these prints, "Standing in front of Joe's work, you feel you are immersed in the weather. It is like the immersion you experience in Mark Rothko's atmospheric color fields. You have the feeling that you can see through the layers."[7] According to Deloris Tarzan Ament, then art critic for the *Seattle Times*, "[In Feddersen's] hands rain is more beautiful than roses," and "Not since Hiroshige's nineteenth-century woodblock print depicting a downpour over a Japanese bridge has an artist so successfully made rain a theme."[8] Wasserman imagined Feddersen "conjuring up the essences of rain—its lulling rhythms and sharp slippery drops, metallic flashes of lightning and permutation of clouds." The "Rainscapes," she wrote, "remind us of how sensual it is to stand unprotected in the rain, to be aware that the environment, far from being something separate, envelopes us absolutely." And in a telling comparison, she related Feddersen's prints to the music of composer Phillip Glass, "who likewise produces shimmering, multiple images that appear simple and repetitive, but are deceptively varied and complex."[9]

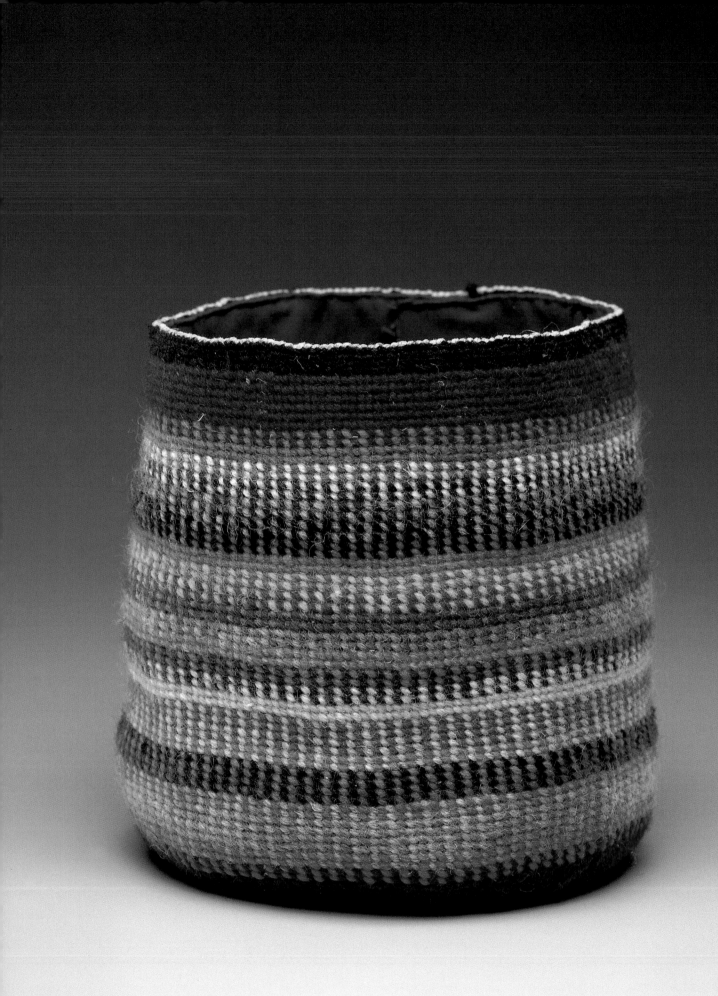

As Lucy Lippard has observed, Feddersen often mixes photography and computer graphics and uses his own silhouette or abstracted form as a "stand-in for humanity," as in such prints as *Darkness* and *Red Chevrons* (both 1989).[10] The silhouette image, Feddersen explained, was derived from his suite of photographic self-portraits, which he then simplified to signify (parts of) himself. But not only is the figuration treated reductively, as a sign, but so, too, is the picture space. As Lippard has written, "The environment is also abstracted into ambiguous space. Sometimes the artist's head and shoulder become a mountain form and sometimes figure and ground merge entirely into a web of patterned color: culture and nature become one."[11]

When *Darkness* and *Red Chevrons* were featured in an important traveling exhibition in 1990, I wrote of them:

> Perhaps the exhibition's most daring and provocative expression of land/self is a series of breathtaking computer prints by Feddersen that fuse figuration and abstraction, art and science, and touch of the artist and technology. Because these anthropomorphic images of land forms are mouse-generated, they blur the distinction between "drawing" and "weaving": the heat transfer printer produces both a waxy surface and a tightly woven dot matrix tapestry of delicate color—salmon pink, mauve, indigo, leaf green. Created on a small scale to avoid the graininess often seen in digitized images, works like *Red Chevrons* are simultaneously futuristic and atavistic. That Feddersen's ideas are going through a machine is obvious, but so is the fact that what emerges on the other side resembles a mythical human-mountain set against a Guatemalan textile. To say that Feddersen's prints are surprisingly inventive is insufficient. He has taken an instrument whose centrality to postmodern culture is liberating and terrifying, and with it he has created something precious, intriguing, and memorable.[12]

The celebrated Cherokee painter Kay WalkingStick also recognized the importance of these experimental prints: "These small-scale works on printout paper have an ethereal mutability that somehow states the precarious human condition. . . . They richly condense multiple forms of self-understanding into powerful visual gems."[13]

In the early 1990s Feddersen created a series of monoprints, such as *Pendleton Image* (1993), which were based on Plains Indian and Pendleton blanket designs. Mixing, as they do, hard-edged designs and watery veils of color, the resultant images seem at home both in the world of textiles and in twentieth-century formalism. Reviewing these prints, Lois Allan noted that "[their] ethereal gradations create a Rothko-like effect, an enveloping cosmos of color." What Feddersen achieves with his admixture of geometry and layers of color, she wrote, are "haunting evocations of an atmospheric space in which the ephemeral and the timeless coexist."[14]

In the second half of the 1990s, Feddersen focused on a handsome series of unique prints known collectively as the "Plateau Geometrics" (figs. 33–46). Instead of forming part of an edition, each print is one of a kind, made with multiple media, including various etching processes, such as aquatint and drypoint, as well as linoleum blocks and blind embossing. In each print a pattern of geometric forms overlays a fine grid structure. While some are characterized by a tight, precise linearity

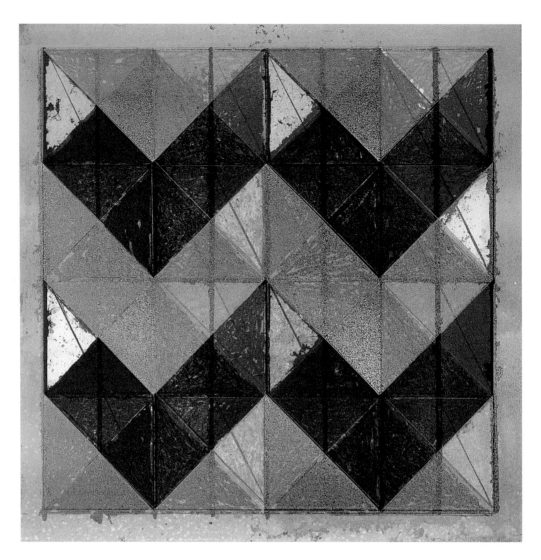

and an unambiguous flatness, others have gestural, painterly edges and complex spatial illusions, with some forms popping up to the surface as others recede, suggesting faraway mountain peaks. Even the best color reproductions do not quite do justice to the subtle nuance and delicate detail of the surfaces of these refined, elegant abstractions. According to Feddersen, this body of work is about homesickness and memories of home: he lives and teaches near Seattle, but his cultural home is on the other side of the Cascade Mountains in eastern Washington. The geometric designs are based on a tradition of "abstract" representation he has seen on baskets and cornhusk bags.[15] He is quick to point out, however, that he is not copying designs but using them as a point of departure. And from tribal elders he has learned that the designs reflect the history of a specific place, embodying a relationship to the land, to its spaces and its light. For Feddersen, then, these prints and the traditional geometric designs that inspire them are the opposite of Jungian archetypal forms, which are supposedly universal;

the Plateau geometric patterns are simultaneously about the history of place and the residual memory of particular natural forms.

Feddersen's goal in the "Plateau Geometric" series was to create beautiful, well-crafted images that manipulated formal elements to suggest "an intriguing cultural undercurrent." He was not interested, he reported, in being a spokesperson or in making didactic art that addressed "the plight of the Native American." He also did not want to focus on any one aspect—form or content, for example—at the expense of another, but sought a holistic work of art that would reflect both his background in traditional culture "back home" and his university studies in modern art.

Part of the finely calibrated power of the works in the "Plateau Geometric" series is their acknowledgment of paradoxicality: they are both open and closed. Process oriented and transparent, always revealing the artist's hand, they are perfectly consonant with the conceptual dicta of modern, geometric, abstract art since the 1960s: intellectually cool, based on structural rigor, and satisfyingly systemic (think Agnes Martin). As such, the "Plateau Geometric" prints are "open" and accessible to a modernist reading based on formalism and the linear logic of "advanced" art. But contained within them are kinds of knowledge—personal and tribal—that are no less codified but are based on poetic responses to living in a particular place. Access to this information is, if not "closed," then certainly experientially restricted. By way of his homesickness, Feddersen gives a glimpse of that knowledge. But because that glimpse takes the form of discrete symbols derived from stylized patterns that are historically and culturally constructed, we must accept that a vast space lies between "here" and "there." Fortunately, the prints seem cognizant of this also, and the fact that they evoke star charts, maps, and graphs means they might well guide us through the interpenetrating indigenous spaces— spiritual, cultural, epistemological—articulated by "Plateau Geometrics."

Feddersen has always tended to work in series, and in this he seems an aesthetic scientist, steadily conducting experiments with materials, forms, and ideas. Kristin Potter has commented thoughtfully on this aspect of his artistry:

> Feddersen's work is about process, and simultaneously engages the viewer in the dissolution and materialization of form and energy. While the individual pieces stand on their own, his preference for working in a series format allows him to proceed organically by oscillating between coherence and gradual evolution.[16]

Feddersen's most recent experiment, which represented the reactivation of an earlier series, resulted in the most recent works in the present exhibition: *Blue Chevron* (fig. 47) and *Blue Chevron II* (fig. 48). Even though his return to the earlier "Chevron" series constituted a reinvigoration of a "personal iconography,"[17] these most recent prints are also organically related (pace Potter) to the "Plateau Geometrics" in their insistent geometry and feverish cartography. These end-of-the-century chevrons were generated with a combination of relief-print processes and silography (waterless lithography). Silography is less toxic than traditional lithography, and therefore healthier for the artist and the environment. And it doesn't hurt that the images, as usual for Feddersen, are delicate, lovely, and complex.

Notes

1. Abby Wasserman, "Joe Feddersen," *Native Vision 3,* no. 2 (May/June 1986), 1.

2. See, Kristin Potter, "Joe Feddersen," in *St. James Guide to Native North American Art* (New York: St. James Press, 1998), 169–72.

3. On *Archives*, see Joe Feddersen and Elizabeth Woody, "The Story as Primary Source: Educating the Gaze," in W. Jackson Rushing, ed., *Native American Art in the Twentieth Century* (London: Routledge, 1999), 174–83.

4. Lucy Lippard, *Mixed Blessings: New Art in a Multicultural America* (New York: Pantheon Books, 1990), 29. See also Lois Allan, "Matched Media," *Artweek*, November 4, 1993: "Feddersen plumbs the personal and often private tensions that shape his mixed identities."

5. Ibid.

6. Joe Feddersen, "Artist Statement," in *3rd Biennial Native American Fine Art Invitational*, exh. cat. (Phoenix: The Heard Museum, 1985).

7. Jaune Quick-to-See Smith, quoted in Wasserman, "Joe Feddersen", 1.

8. Deloris Tarzan, "Artist Gives Free Rain," *Seattle Times*, February 6, 1984: D5.

9. Wasserman, "Joe Feddersen," 1.

10. Lippard, *Mixed Blessings*, 29.

11. Ibid.

12. W. Jackson Rushing, "Contested Ground," *New Art Examiner* 19 (November 1991): 27–28.

13. Kay WalkingStick, "Native American Art in the Postmodern Era," *Art Journal* 51 (Fall 1992): 16.

14. Lois Allan, "Culture and the Postmodern," *Artweek* 21 (October 25, 1990).

15. Except as indicated, all quotations from Joe Feddersen are taken from a series of conversations with the author in 1996.

16. Potter, "Joe Feddersen," 171.

17. Joe Feddersen, conversation with the author, December 29, 2000.

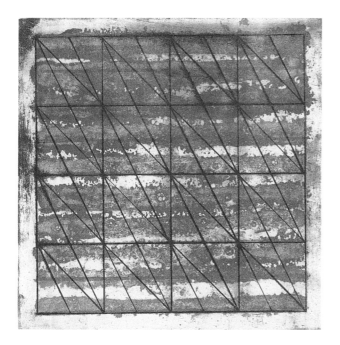

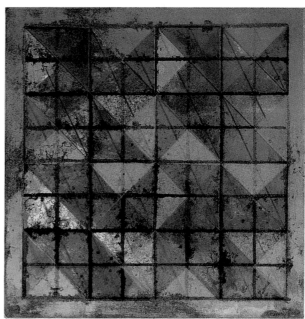

Clockwise: 34. *Plateau Geometric 98*, 35. *Plateau Geometric 128*,
36. *Plateau Geometric 129*, 37. *Plateau Geometric 149*. (See also p. vi)

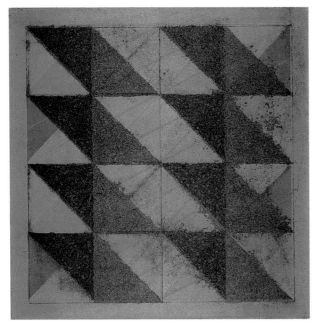
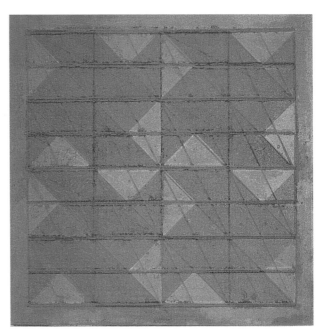

Clockwise: 38. *Plateau Geometric 169*, 39. *Plateau Geometric 175*, 40. *Plateau Geometric 180*, 41. *Plateau Geometric 185*

Joe Feddersen

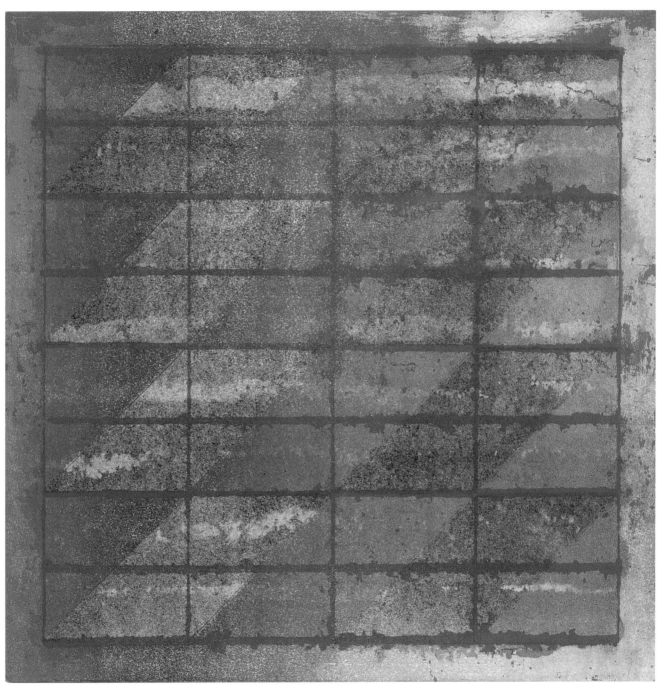

42. *Plateau Geometric 190*

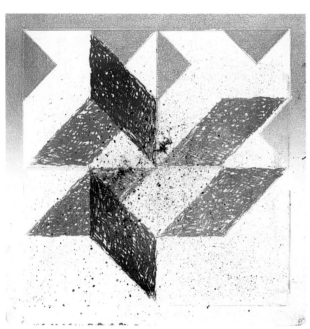

43. *Plateau Geometric 192*

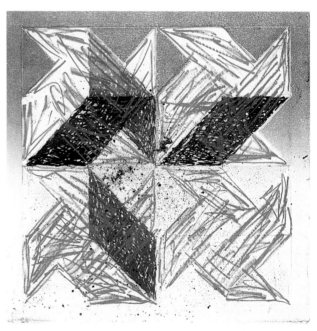

44. *Plateau Geometric 194*

Joe Feddersen

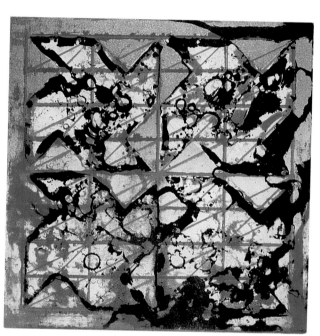

45. *Plateau Geometric 196*

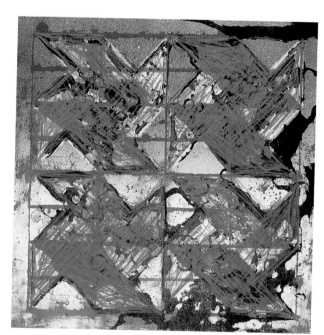

46. *Plateau Geometric 197*

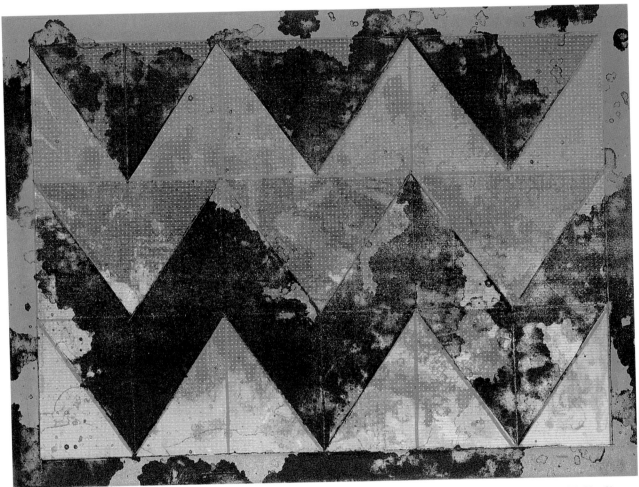

47. *Blue Chevron*

Joe Feddersen

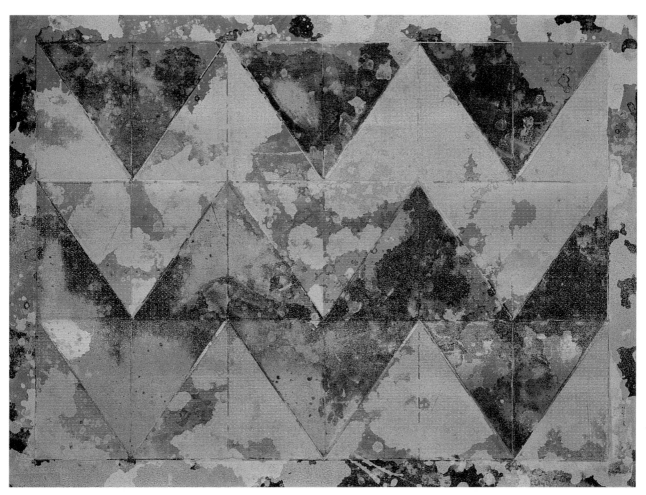

48. *Blue Chevron II*

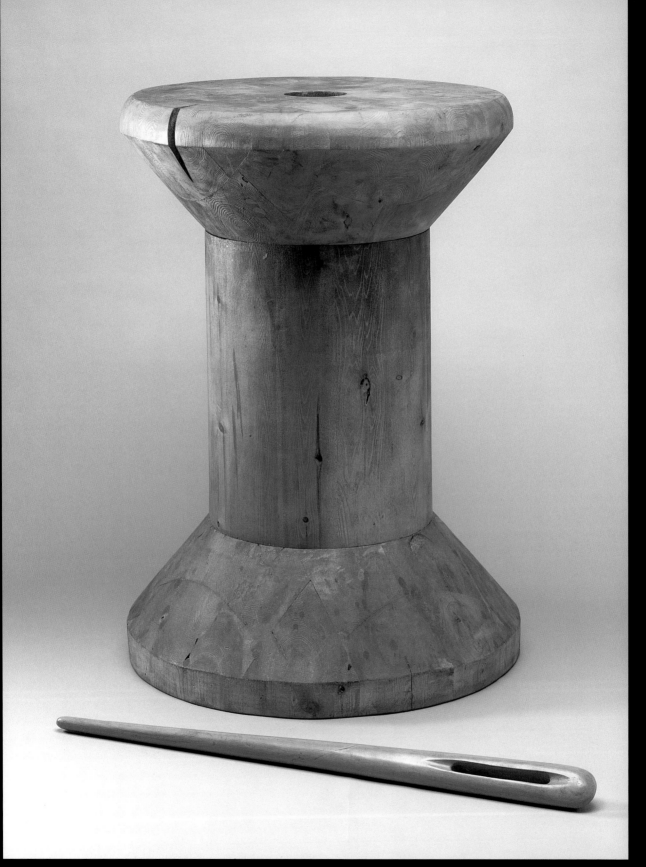

49. *Metissage*

Teresa Marshall:
"Wear the Media" Is the Message
Mi'kmaq

Colleen Cutschall (Lakota)

Teresa Marshall (b. 1962), a Mi'kmaq artist from Nova Scotia, has made an important contribution to the politics of cultural identity in Canada. In a series of solo and group exhibitions she has shown important works in a broad range of sculptural media that are both topical, in the political sense, and conceptually clever. The examples of her artwork in the Eiteljorg's 2001 Fellowship exhibition are brilliantly postmodern as they play, literally and symbolically, with both visual and verbal structures. Marshall is a graduate of the Nova Scotia School of Art and Design, one of Canada's leading art schools, which has long been noted as a center for conceptual art and critical theory. It is not surprising, then, that politics, puns, and poetics underscore Marshall's work, which displays, with great artistic depth, an understanding of binary oppositions. This exhibition represents her art in the culminating decade of the twentieth century, including sculpture, painting, printmaking, assemblage, and installation media, all of which she manipulates with an intuitive and sensitive attention to aesthetics and craftsmanship. Her practice has absorbed and honored aboriginal technologies such as stretched animal hides, which extend the boundaries of their traditional applications.[1]

In *Metissage* (fig. 49), her sculptural installation of cedar, tobacco (not pictured here), and stone, the viewer confronts an oversized thread spool and a quartet of four-foot-long stone needles. Indeed, Marshall has been "sewing up" old colonial business since 1991. *Metissage* also speaks to women's domestic work as a source of survival in the twentieth century. Other Canadian artists, such as the

Inuit textile artist Jesse Oonark (1906–1985), have relied on sewing skills and were inspired to produce works of technical superiority and outstanding design. Oonark had left her needle and thread inserted in the piece she was working on at the time of her death, her presence still observable. Marshall, in turn, says that the over–life-size *Metissage* is out there for the ancestors as an emergency repair kit for the earth.

The visual and cultural language that Marshall utilizes with humor, strategic precision, and dexterity recalls the historically high incidence of multilingualism among aboriginal nations. Oral language traditionally has been augmented in aboriginal conversation by either an older, gestural, symbolic language or an intuitive and penetrating silence. Marshall's unquiet reversal of scale within objects creates extreme trompe-l'oeil effects, effectively jolting the viewer's gaze, necessitating a reality adjustment. In Marshall's art, presence and absence are observable, tactile, and simultaneous.

Another example of how Marshall manipulates scale and takes on the role of the trickster is in the piece titled *The Monopoly Game* (1991), which is an obvious play on a favorite North American board game. But Marshall's "board" is a 12' x 12' canvas on the floor. Prices for property are labeled "Oka" (the site of a recent conflict between Mohawk warriors and the Quebecois paramilitary), "500 years" (a reference perhaps to the Columbian quincentenary in 1992), "The Indian Act" (repressive nineteenth-century legislation), and so forth. In the "Jail" corner there is a reminder that aboriginals who land on this spot are not "Just Visiting." The draw cards are labeled "Small Pox," "10 Hell Mary's," "Justice Denied," and "Back to Jail." The larger-than-life carved wood game pieces—including images of soldiers, tanks, and the Canadian maple leaf turned upside down—represent colonization. The scale of the game influences how the body responds to it. At first the audience is titillated by the familiarity of the game and by its enlarged scale, but then they find themselves wanting to play the game in its usual fashion but with Marshall's unusual pieces and properties. The interactive characteristic transcends meaning, and the content expands our points of view.

As an aboriginal artist and writer, I have read the visual texts of Marshall's creations with extreme pleasure. Her works speak with a vocabulary that is comforting and familiar, like a set of relaxed bones in an easy chair. I was ecstatic at her exploration of the human body through the metaphor of the animal body. Her symbolic language is rich with purpose and meaning. Marshall's informed understanding of the use and application of wildlife and plant materials as living media flays current concepts of "postnatural" art. Her unique aesthetic also identifies the potential absurdities in cross-cultural communication. Some contemporary cultural postulations totally disregard the common belief of traditional Native people that Nature is the macrocosmic myth within which humans are a microcosm. As in older (historic) Native art forms produced largely of natural materials, this macro-microcosmic dialogue coincides with the anthropological tendency to use the part to represent the whole. Marshall has skillfully dissected the body into its elemental forms—intestines, bones, blood,

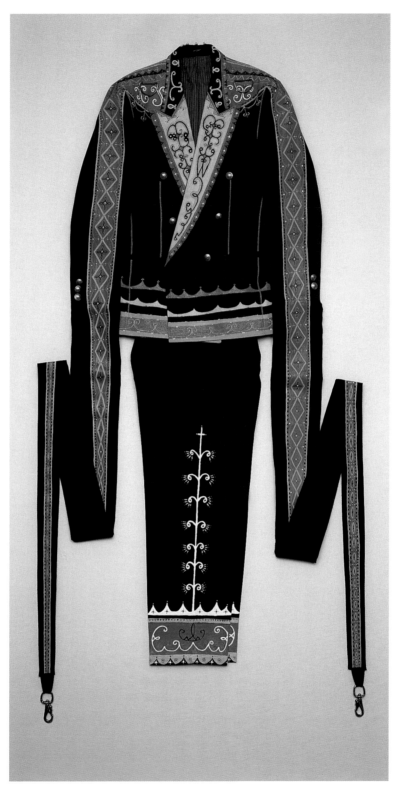

50. *Bering Strait Jacket #1*

"Wear the Media"

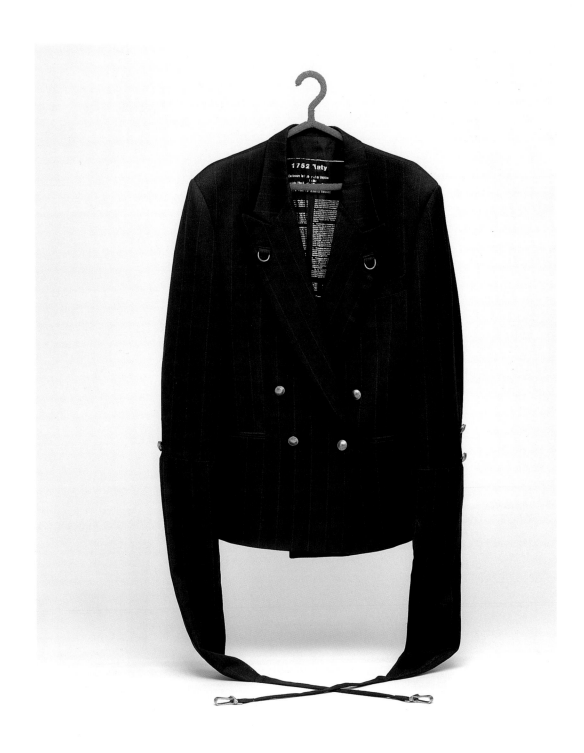

51a. *Bering Strait Jacket #2* (closed)

Teresa Marshall

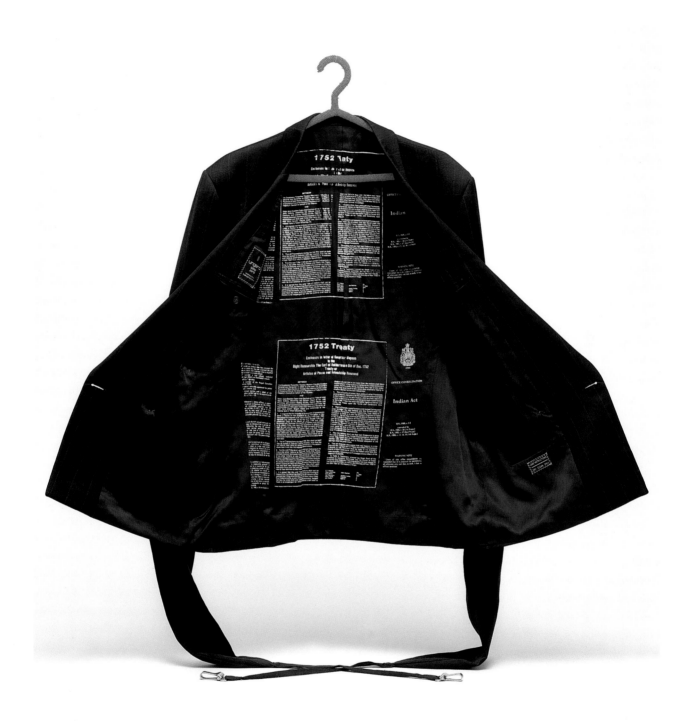

51b. *Bering Strait Jacket #2* (open)

"Wear the Media"

organs, flesh, hair, voice—only to reassemble their message without losing any of their indigenous meanings in their application independently or in collaboration with other media.

The part represents the whole; for example, the hide represents the whole animal, and its particular characteristics and powers remain with the hide. These powers can be borrowed by the person who wears the hide to increase personal power and to protect him or her not just from the elements but from spiritual danger as well. This is why aboriginal people chose the names of animals for themselves, why they wore the animal's clothing, and why they danced like the animals.

Marshall's effort to make the artworks speak, such as through the stringed drums of *Pressing Issues* (fig. 52), lose none of their voice in spite of the absent drummer. Created originally for the exhibition *Band Stands* (1997), *Pressing Issues* consists of instruments made by stretching hide over ironing-board frames and stringing the resultant cellolike instrument with babiche (strips of rawhide). The shape of the hide structure is reminiscent of a grave marker and recalls ancestral drummers. Marshall thus presses the question "Why can't you settle things from the past or write aboriginal history through our eyes?" Marshall is not just making art; she is trying to effect change for a very divergent audience—us, them, and the ancestors.[2]

As an aspiring ancestor, open to communication and intervention from those who are already ancestors, Marshall gives us *Moccasin Telegraph* (fig. 53), which comes complete with legs. The hide-covered telephone and spindly-legged table might interest some of those ancestors, who might be tricksters, crabby, mean, or benevolent. Ultimately Marshall recognizes that the ancestors lead us toward our destiny, which depends on how we meet our challenges as apprentices. Sometimes they use a "moccasin telegraph," and sometimes they pinch or shove us in the appropriate direction and teach us all to ask better questions.[3]

The use of gender-specific hides was consistent in areas of North America where hide clothing was most prevalent. Male elk hides were used for men's clothing, and female hides for women's clothing. The hide was tanned by using the animal's brains to break down skin fibers, the rule of thumb being that every animal had enough brains to tan its own hide! Hide work was one of the most valued aboriginal women's skills until the beginning of the twentieth century. This labor-intensive practice was diminished with the introduction of trade goods, hunting restrictions, and depletion of resources.

Native art reflects the instinctual parts of our self and our history as they relate to our evolution over three millennia. Scientific classification, on the other hand, was a methodology generated during the rise of museums of natural history and ethnography in the nineteenth century. Questions regarding the ancient ways of aboriginal Americans were always framed by an assumption of European cultural superiority. Art was not distinguished from material culture in Euro-American museums until well into the twentieth century. Crowded and improperly lit displays, near-total lack of curatorial vision, focus on common rather than outstanding objects, lack of proper labeling, and poor provenance were typical problems in the exhibition of non-Euro-American art before the 1930s. Bone,

horn, animal skins, feathers, hair, and the (art) objects made from them were associated with indigenous cultures that were assigned to the bottom rung of the evolutionary ladder.

Neoclassical and Romantic artists were the first to capitalize on animals and non-Euro-American cultures as exotic subjects for art, a practice that has continued to this day. Modern artists in the late nineteenth century were struck first by the stylistic and emotional power of primarily the archaic arts and only later (ca. 1906) the tribal arts. Following this the Surrealists discovered the intellectual, psychological, and spiritual power of tribal arts. Although women's arts never really enjoyed much serious attention from art institutes in Europe, museums became even more disdainful of fine domestic craft, perhaps because Native art was assessed within the political, evolutionary, and industrial ideals of Western Europe. It wasn't until the 1970s that environmental artists began a recovery—through the creation of earthworks and the use of natural materials—of the meanings of art-making in its earliest forms. The interest of modern artists was never directly focused on the tribal arts for their own sake, but as a resource for revitalizing Euro-American art. The myth of the primitive has always been a primary motivation for the interest in tribal arts. Perhaps this is because, as Marshall notes, most people are too cerebral and are therefore not looking closely at the environment.

Marshall's *Den of Inequity* (1985) features slithering and coiled serpents made from fifty men's neckties and filled with rice. She incorporates in her work the traditional use of gender-specific materials for clothing—in this case, neckties. Politically, she equates the "snakes in the grass" with Indian agents and colonizers, either of whom might strike at any moment. They represent a minefield of cultural and gender issues. Marshall's message is this: "Proceed with caution, and remember the lessons of elders and ancestors."[4]

In opposition to the serpents are *Bering Strait Jacket #1* (fig. 50) and *Bering Strait Jacket #2* (fig. 51 a,b). These jackets, with their long, snakelike sleeves, are painted in memory of Marshall's great grandfather's Great Coat and are hung from companion ladderlike structures. Marshall sees the serpents of the *Den of Inequity* working up the ladder of colonialism. The Canadian Indian Act (1876), which defined who was Indian, is silk-screened to fabric with snakes and ladders on painter's canvas. More than a political statement on anthropological theory, these works allude to the integration of human and animal worlds and the ability to pass from one to the other. This coexistence of human/animal and male/female design features emphasizes the transforming powers of the artist. Marshall's fair physical appearance has allowed her to examine the role of race and color in the art world and to slip quietly like a scout into the dominant world and develop intellectually. Through her art, she shares with her family and community the hard truths she has discovered. But she does not necessarily work toward divisiveness; instead she only points out the truths that are necessary to balance two worlds and two histories.

Marshall has hopes that her art will work as a segue, allowing First Nations culture to "proceed without pause." A meaningful historical segue, for Marshall, would include the passing on and the

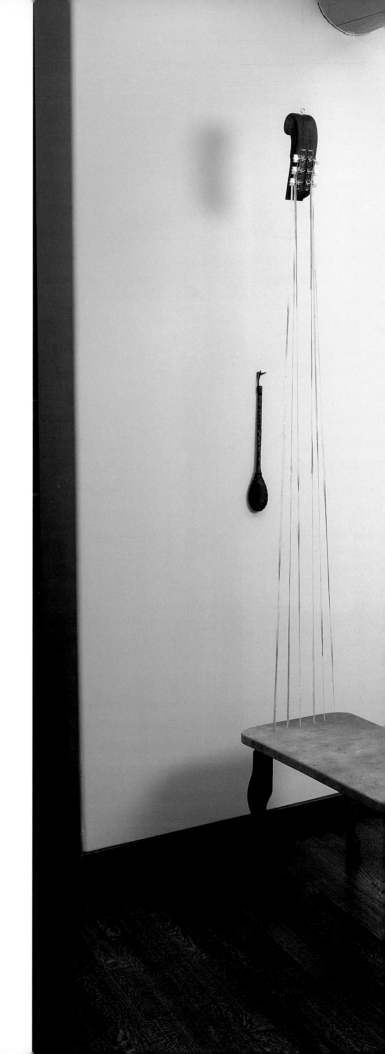

52. *Pressing Issues*

Teresa Marshall

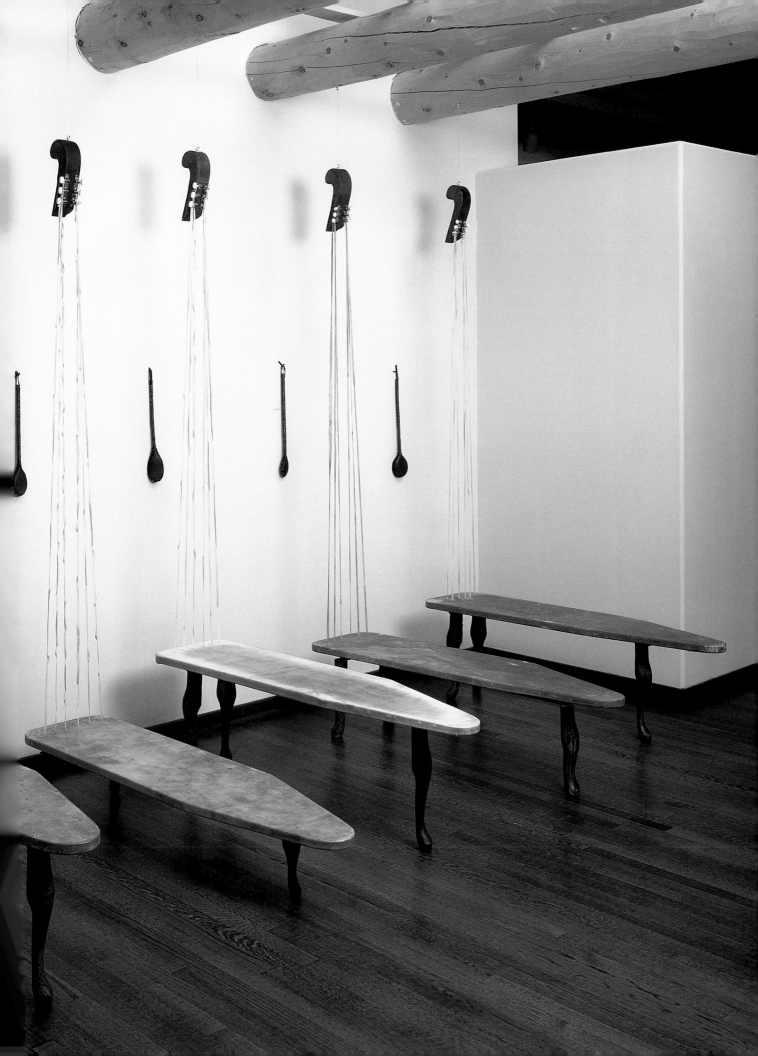

carrying through to the next generation of the values of her ancestors. Similar to her use of the ladder as a symbol for the backbone of First Nations civilization, her creative process is understood as the digestive system, operating instinctively at gut level. Her aesthetic is transformative at the intellectual level and synthesized at the heart or organ level when it reaches the spiritual plane. With the ancestors witnessing her progress, Marshall says that she not only fashions things with her hands but also with her heart. Therefore, everything that she makes—be it a basket, a design, or a prayer—is a thought representing good energy. Consequently, every stitch or creative act is important and had better be good. Her craftsmanship is the hallmark and the gift of the artist ancestors, which she reciprocates.

Notes

1. On Marshall, see Diana Nemiroff, Robert Houle, and Charlotte Townsend-Gault, *Land, Spirit, Power* (Ottawa: National Gallery of Canada, 1992), 195–203; Melanie Fernandez et al., *The Deportment of Indian Affairs*, exh. cat. (Toronto: A Space, 1995); Janet Clark and Charlotte Townsend-Gault, *Band Stands: Recent Work by Teresa Marshall*, exh. cat. (Thunder Bay, Ontario: Thunder Bay Art Gallery, 1997); W. Jackson Rushing, *Teresa Marshall: A Bed to the Bones*, exh. cat. (Vancouver, B.C.: Contemporary Art Gallery, 1998); and the extensive bibliography in Kristin Potter, "Teresa Marshall," in *St. James Guide to Native North American Artists* (London: St. James Press, 1998), 350–54.

2. Interview with Teresa Marshall, December 26, 2000.

3. Ibid.

4. Ibid.

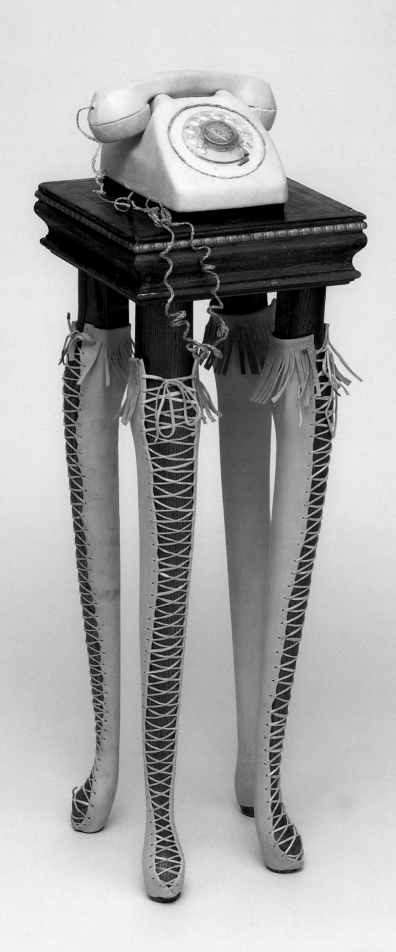

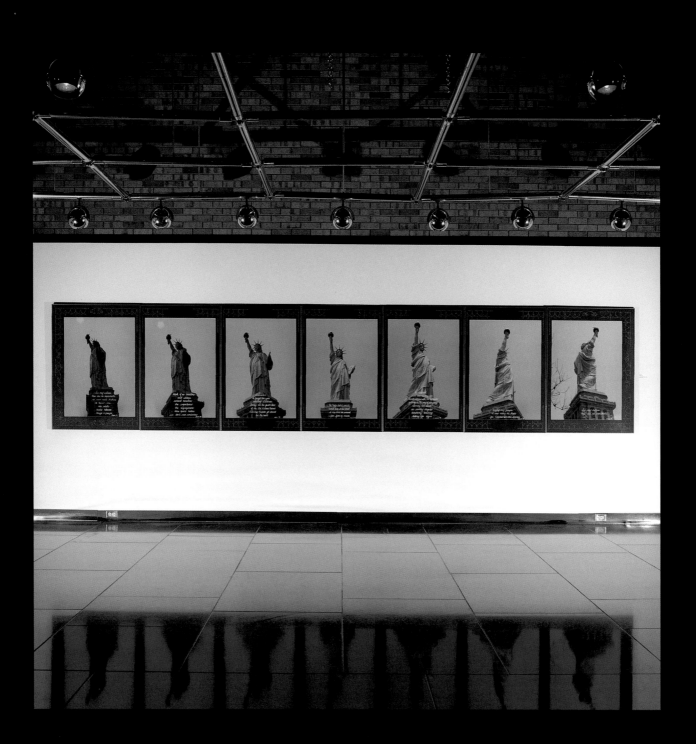

54. *For Fearless and Other Indians.* (Photo courtesy of Indian Art Centre, Dept. of Indian and Northern Affairs)

Shelley Niro: Flying Woman

Bay of Quinte Mohawk

Lee-Ann Martin (Mohawk)

Shelley Niro (b. 1954) moves easily among multiple media—photography, poetry, film, beadwork, painting, sculpture, and storytelling. She is recognized especially for the outrageous humor and teasing wordplay in her most celebrated series of photographs, *Mohawks in Beehives* (1991) and *This Land Is Mime Land* (1992). With the exception of her feature film *Honey Moccasin* (1998), the works selected for this exhibition mark a departure from Niro's trademark humor. We are invited instead to enter into the artist's preoccupation with memorials to distant ancestors and close family members, to lost nations and tragic histories.

For Niro, Flying Woman is the archetype of freedom and abandonment, representing the "subconscious as it passes through time and space,"[1] yet, at the same time, this figure references the artist's strong respect for cultural traditions. Niro's works disrupt the stereotypes and misconceptions of Aboriginal[2] peoples as the "vanishing race." Her art emerges in the tension between honoring ancestral traditions and acknowledging the right to find daring and innovative ways to proceed into the future. Niro acknowledges the need to incorporate traditional elements into her art while continually challenging herself to be inventive. Thus she plays a very important role in confronting the continuing polemics around both the imminent extinction of Aboriginal cultures and the construction of self in Euro-American society.

Niro is a member of the Mohawk Nation, Iroquois Confederacy, Turtle Clan, Six Nations Reserve. Born in 1954 in Niagara Falls, New York, she lives with her family in Brantford, Ontario, at the edge of the Six Nations Reserve. Niro graduated in 1990 from the Ontario College of Art with an honors degree in fine art, majoring in painting and sculpture. She received her Master of Fine Arts

degree from the University of Western Ontario, London, in 1997. Her thesis addressed the rediscovery and readdressing of the history of Iroquois people. In particular, she researched the diaspora of the Mohawk Nation after their departure from the Mohawk Valley in New York State following the American Revolution, when they settled in what is now known as the Six Nations Reserve outside Brantford, Ontario.

Niro is perhaps best known for her photographic works from the early 1990s, which effectively employ her unique sardonic humor as she confronts stereotypical images of Native women within contemporary society. Photography and First Nations have had, until recently, an uneasy relationship. Aboriginal photographers today are painfully aware of the history in which images of Aboriginal peoples by Caucasian photographers contributed to a master narrative of a "noble savage" frozen in time, at best, and a "vanishing race," at worst.

Today, many Aboriginal photographers seek to record and acknowledge contemporary activities and individuals that historically have been largely excluded and misrepresented. Similar to the artistic strategies adopted by many Aboriginal photographers, Niro creates poignant visual narratives that transcend the limits of the single portrait. Frequently, she further develops the narrative with the application of hand tinting to the black-and-white photograph and the addition of text. Cinematic in approach, Niro's multiple-image sequences extend the dialogue and rhythm in a manner similar to that of a short movie. Her characters are performers in self-consciously staged photographs that reveal her mastery of camp humor and costume. Niro's construction of her intelligent narratives from the perspective of a theatre or film director is comparable to the approach of the photographers Jeff Wall and Cindy Sherman. This cinematic aesthetic continues to distinguish Niro from other First Nations photographers. Her photography and film transcend an obvious, uncomplicated dismissal of the uneasy history between Aboriginal and Caucasian peoples.

Before examining Niro's cinematic approach to photography, it is important to discuss her film *Honey Moccasin*, an irreverent forty-minute satire on the popular television genre of detective drama. The stage is a contemporary reserve, "a Reservation X otherwise known as the Grand Pine Indian Reservation." This film is important for its attention to the conflicts, misunderstandings, jealousies, and seeming contradictions that are always present in human relationships. The richly layered narrative emerges around a plot in which someone has stolen every dance outfit in the community. Niro brilliantly combines traditional imagery with contemporary performance art as the characters seek to identify the thief. Her message is clear—Aboriginal people can choose to respond to the theft of tradition with daring and imagination, suggesting that "being Indian takes more than feathers and beads."[3]

A park in Brantford, Ontario, is the stage in one of Niro's most compelling series of photographs, *Mohawks in Beehives*. Niro's sisters pose with a statue of Joseph Brant, the Mohawk diplomat and military leader for whom the town is named. The impetus for this series was the need for emotional

release from the damaging and depressing events surrounding the Oka Crisis in the summer of 1990[4] as well as the Gulf War in early 1991. Niro playfully positions her sisters in a symbolic reclamation of the town. Paul Chaat Smith notes that "the images of strong, confident Native women in Brantford, walking the streets and posing before statues on their terms, neither victim nor symbol, found great resonance with a wide audience."[5] Used as a framing device, beadwork designs further reinforce the artist's respect for the centrality of the matriarchal structure in Iroquoian society. The juxtaposition of elements from traditional art with the bold camp humor of the central figures reveals the sometimes tense intersection between traditional cultural knowledge and Aboriginal people's contemporary sense of identity.

Niro's works continually reference Mohawk women's art traditions as she challenges popular notions of beauty and the commodification and representation of Aboriginal women. Niro presents herself and her family as ordinary and representative of Aboriginal people in North America today. In doing so, she enhances access and understanding with Native audiences while deconstructing preconceived notions of identity to prove that "you're Indian no matter what you do."[6]

In the series of triptychs *This Land Is Mime Land*, Niro positions herself on either side of a central image of a family member. In a work from this series, *North American Welcome*, she ironically presents herself as the Statue of Liberty—an icon that embodies a sense of American nationalism and identity. As Liberty, she addresses the often-conflicting notions of cultural histories and contemporary realities within North America today and adds a new meaning to the phrase "taking Manhattan." This body of work has been compared to that of a generation of women artists—including Shawna Dempsey, Lori Millan, and Diana Thorneycroft—who "share a sense of exploration and of movement toward a new future for women, a future of greater ownership by women of psychic/cultural space."[7] Niro and these artists often use images of women—often self-imagery—in their work. According to curator Jan Allen, the use of costumes and masquerade may emphasize the idea of a feminine self under construction and the female body as a source of empowering identity.[8]

Niro extends her critique of the meanings surrounding Liberty as a very powerful monumental icon in seven large-scale photographs of the statue in a work titled *For Fearless and Other Indians* (fig. 54). Niro assigns a Native American meaning to this popular Euro-American symbol of freedom and liberty. For the original inhabitants of this land, Liberty is a painful reminder of displacement and alienation in our own home.[9] In the poem that accompanies *For Fearless and Other Indians*, Niro chronicles a history of this land and the differences that continue to define contemporary existence (see sidebar at right).

Niro's recent works reveal her sensitivity in honoring ancestral traditions, yet she consciously and consistently rejects a romantic idealization of the past. In the large photographic installation *Final Moments Thinking of You* (fig. 57), she creates a memorial to those who have passed before us. Her richly colored and textured photographs encompass images depicting the four basic elements for sur-

*In my culture
there are no monuments
no man-made structures
no tourist sites
one visits
burns tobacco
says a prayer*

*think of our elders
and ancestors
remind ourselves
the importance
the significance
this space holds
we don't need reminders*

*I remember
I forget the year
reading L'il Abner
living on the fourth line
of the Six Nations Reserve
Fearless Fosdick got stabbed
in the heart.
The knife had to remain
buried deep in his chest
It couldn't be removed
or he would bleed to death.*

*He survived
and went about his daily life
and routine with that
big handle
getting in the way of
everything.*

*I now roam the earth
in earthly disguise
and constantly search*

*looking for signs
saying prayers
continue to carry the blade
for Fearless
and other Indians*

*In my culture
there are no monuments*

—Shelley Niro

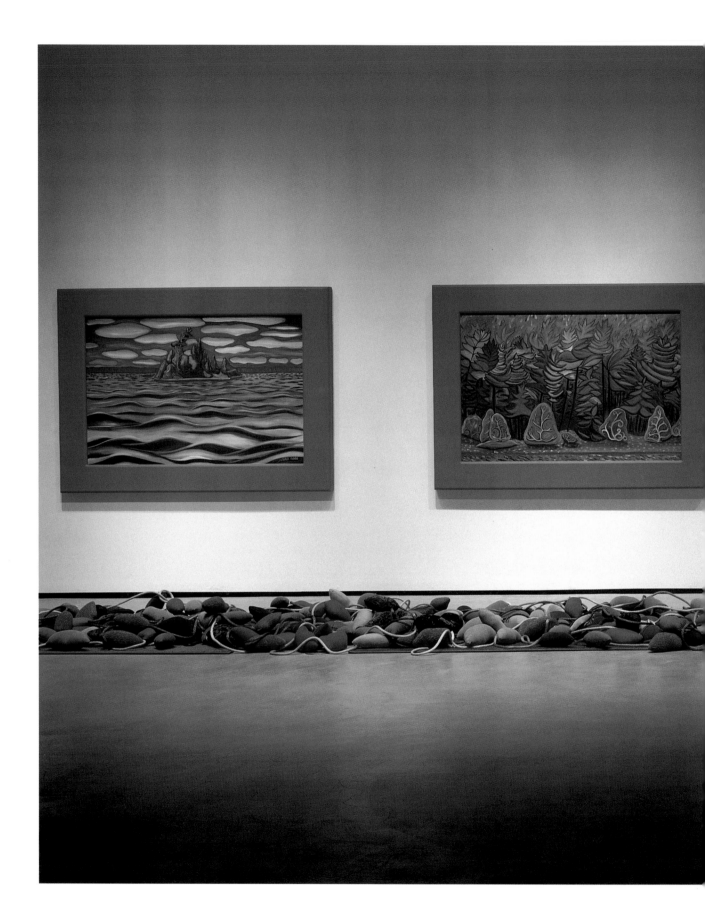

Shelley Niro

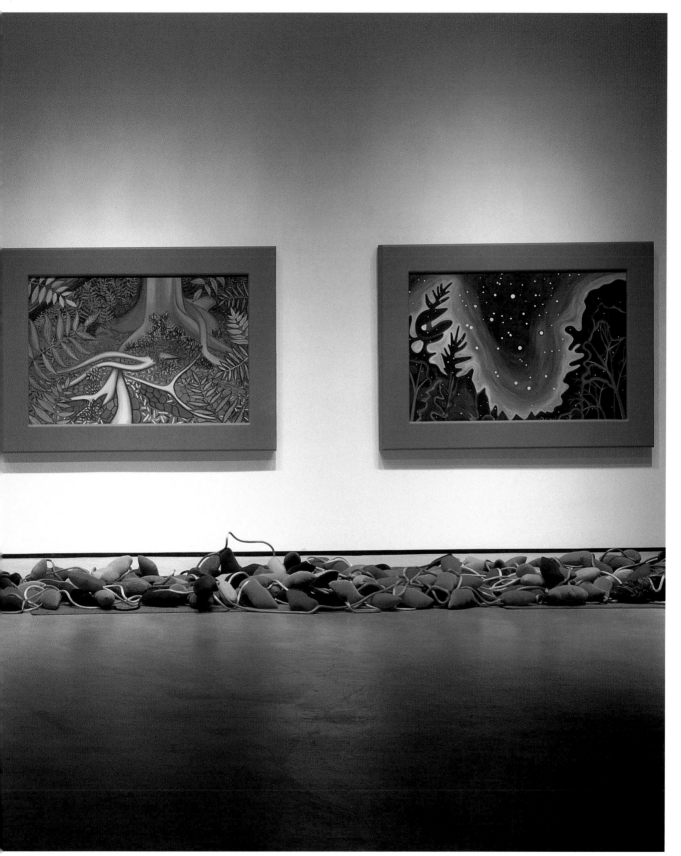

55. *Unbury My Heart.* (Photo by Isaac Applebaum, Toronto)

Flying Woman

vival—water, earth, fire, and air—which define for the artist an inherent spirituality. The arrangement of the twelve photographic panels suggests a stairway or guiding path to the skyworld. Niro again uses an isolated detail of Iroquois beadwork as the top-central image to reinforce the importance of history and religious beliefs. She proposes that culture affords a safe and stable foundation for our journey to the skyworld.

Niro continues to work with paint, her first medium of choice, at times in combination with photographs and mixed media. In the mixed-media installation *Unbury My Heart* (fig. 55), she provides an emotional reminder of the legacy of Aboriginal peoples to this land. Four large-scale paintings again depict images of the four elements in landscape formats. In creating these lush paintings, Niro was greatly influenced by two disruptive events during the summer of 2000—devastating forest fires in New Mexico and tense disputes between Mi'kmaq and Caucasian fishing communities in Atlantic Canada. The intimacy and immediacy of the earth painting is intended to draw the viewer into a place of solace, comfort, and protection. Bearing witness to the sacredness of the four elements, five hundred stuffed velvet heartshapes are linked together on a red velvet carpet. These hearts represent the five hundred Nations of North America—the heartbeats of this land and its original peoples. Influenced by Dee Brown's book *Bury My Heart at Wounded Knee* (1970), this work demands recognition of the historical and contemporary issues that impinge upon treaty rights and natural resources on this continent. Her "heartbreaking" history reminds us that settlement and resource exploitation are carried out at the expense of traditional Aboriginal homelands.

The painting *Tutela* (fig. 56) depicts an area of the Grand River near Brantford, Ontario, where the Tutela lived in the early nineteenth century. According to historical texts, the Tutela moved eastward, seeking refuge from the Indian Wars on the Plains, before being decimated by disease. Other accounts say that the Cayuga, who preserved many Tutela ceremonies and songs, adopted the Tutela into the Iroquoian community. Oral history tells another story of extermination at the hands of settlers. To Niro, this area of the Grand River, once inhabited by the Tutela, provides a psychological and spiritual home in which she pays respect to, and is constantly reminded of, extinct Aboriginal nations. Her paintings of the land and photographs of natural elements become powerfully charged with acknowledgement of her place within Iroquoian history and contemporary society.

Niro extends the image of Tutela Heights, an area just outside Brantford, Ontario, with a further sense of history, land, and identity in her first film, *It Starts with a Whisper* (1993), codirected with Anna Gronau. In a contemporary version of a "vision quest," this road movie takes a young Iroquoian girl, Shanna, from Tutela Heights to Niagara Falls. Her aunts accompany her as guardian spirits. Their journey (and the film) ends between the last seconds of 1992 and the first seconds of 1993. Firework explosions over the falls and elaborately choreographed music composed by Niro's brother, Michael Doxtator, mark this moment. The dramatic display transforms into the shapes of a turtle and the tree of life. The powerful conclusion symbolizes the lesson that Shanna learns in this coming-of-

age epic—that knowledge of the past does not prevent her from living in the present, nor from embracing the future. Niro's characters are metaphors for Aboriginal peoples throughout the Americas, for whom 1992 marked five hundred years of colonization and, at the same time, signaled a hopeful turning point in the uneasy relations between the descendants of the original colonizers and the original peoples. It is fitting to conclude this chapter with Niro's own comment on the film: "It was designed so that it would be shown New Year's Eve of 1992 . . . so that the screening of the film would end at midnight, so we'd catapult ourselves into the rest of the history of the world."

As Niro catapults herself into the future, she continues to be motivated by a vision that combines her healthy respect for historical traditions and an outrageous sense of innovative freedom.

Notes

1. Jennifer Vigil, "Shelley Niro," in *St. James Guide to Native North American Artists*, ed. Roger Matuz (Detroit: St. James Press, 1998), 415.

2. In recent discourse by First Nations people about First Nations art, culture, and politics in Canada, the word "Aboriginal" has frequently been capitalized as a proper noun referring specifically to the native people of Canada. In this chapter, where the word is used in that sense, rather than as a generic term for indigenous people, it is thus capitalized.

3. Paul Chaat Smith, "Home Alone," *Reservation X: The Power of Place in Aboriginal Contemporary Art*, exh. cat. (Hull, Quebec: Goose Lane Editions and Canadian Museum of Civilization, 1998), 111.

4. The Oka Crisis, as it was called by the Canadian media, developed in Kahnasatake Mohawk Territory near Oka, Quebec. Outraged by the town's plan to construct a golf course on the ancestral burial ground, members of Kahnasatake and other Aboriginal communities mounted a seventy-nine-day standoff against provincial and federal military forces. For Aboriginal people in Canada, the Oka standoff is a symbol of the legacy of continuing injustices.

5. Chaat Smith, "Home Alone," 110.

6. Lawrence Abbott, "Interviews with Loretta Todd, Shelley Niro and Patricia Deadman," *The Canadian Journal of Native Studies* 18, no. 2 (1998): 355.

7. Jan Allen, *The Female Imaginary*, exh. cat. (Kingston, Ontario: Agnes Etherington Art Centre, 1995), 7.

8. Ibid., 8.

9. Barry Ace, *For Fearless and Other Indians*, exh. cat. (Hull, Quebec: Indian Art Centre, 1998), unpaginated.

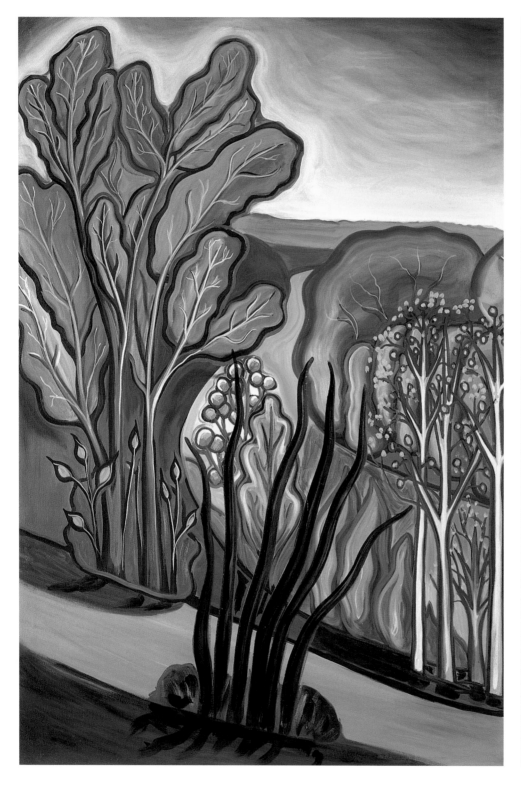

Shelley Niro

56. *Tutela* (triptych)

Flying Woman

58. *I Sat on a Riverbank and Waited for Signs of Life*

59. *One Day in March*

Shelley Niro

60. *Erratic Love Song*

61. *Here*

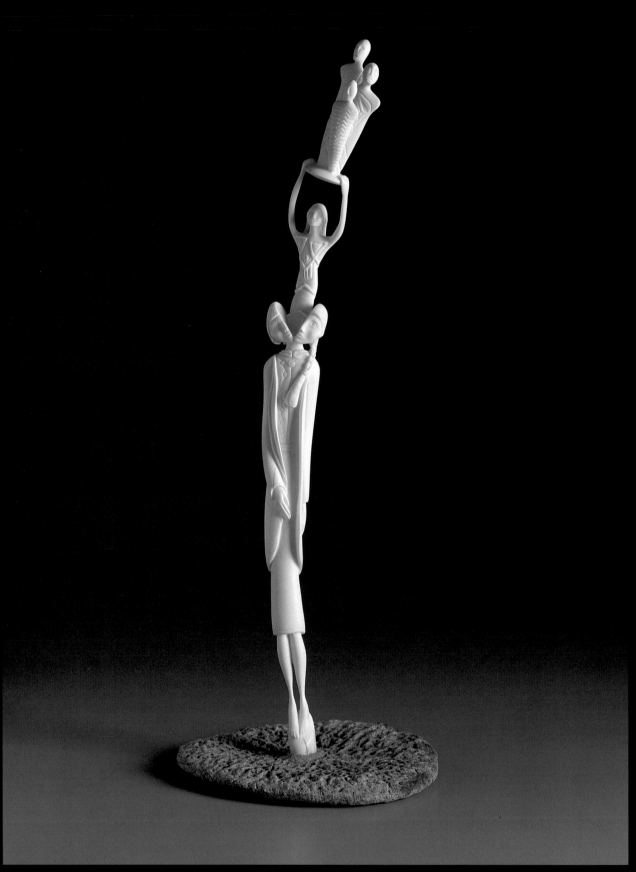

62. Untitled, standing figure with figures emerging from head

Chapter Six

Susie Silook:
"Simultaneous Worlds"
and the Yupik Imagination

Siberian Yupik/Inupiaq

Janet Catherine Berlo

Contemporary sculptor Susie Silook (b. 1960) conjoins a modern political activist spirit with a profound respect for the indigenous artistic, cultural, and religious traditions of the Arctic. Walrus ivory is the most prominent material in her mixed-media work, often used in concert with other essential animal materials from the North: whale bone and baleen, seal whiskers, polar bear hair, walrus stomach, and sinew. Some of Silook's works, such as *Seeking Her Forgiveness* (fig. 65), address themes that have been prominent in Arctic art for hundreds of years. Others address issues of colonialism, missionization, and cultural conflict.[1]

Silook is both a creative writer and a visual artist.[2] Her mother was of mixed Inupiaq (North Alaskan Eskimo) and Irish heritage. Her father's side of the family is Siberian Yupik[3] and includes a distinguished lineage of hunters, artists, writers, and archaeological workers. Her father, Roger Silook (b. 1923), has sold carvings of ivory and whalebone to collectors and museums. *Seevookuk: Stories the Old People Told on St. Lawrence Island*, his account of traditional ways of subsistence, was published in 1976.[4]

Even in the twentieth century it was unusual for an Alaskan woman to learn to carve.[5] Carving obdurate materials was traditionally male work, just as fashioning hide, skins, sinew, and intestine into clothing was woman's domain. But Silook claims she was just never very good at sewing. Yupik women have a phrase, she says, for women who are clueless about feminine traditions: "'She doesn't

even own a thimble,' they say in disgust. That's me—I don't even own a thimble!" In contrast, she was drawn to the work of her father and other men. "He never said 'Girls can't carve,' like some men say. So I learned how to carve."[6]

Although she lives today in Anchorage, Silook's ancestral home is the village of Gambell, on St. Lawrence Island. The island is a hilly, treeless, windy place, one of the few visible promontories of what, in ancient times, was the land bridge over which Asiatic hunters walked as they colonized the Americas. At over one hundred miles in length, it is the largest island in the Bering Sea. From Gambell, at the northwest tip of the island, if weather conditions are right, one can see Siberia, just forty miles away.

Walrus ivory is an appropriate medium for an artist from St. Lawrence Island. From time immemorial, its Siberian Yupik inhabitants hunted walrus and other marine mammals, which, until the twentieth century, were the mainstay of their diet and material culture. When male walrus hunters brought home their harvest, the thick, sturdy hides provided materials for boats, tents, ropes, and clothing. Women devised ingenious waterproof parkas from walrus and seal intestines. Walrus blubber powered the lamps. Walrus stomach membranes were stretched as drums for ceremonial performance, and as sails for boats.[7] And of course durable and handsome walrus tusks were carved for artistic, spiritual, and practical use. While more perishable materials long ago disintegrated, the strong dentine material of walrus tusks has survived through the centuries, providing an astonishing picture of the rich artistic inventory of ancient people of the Bering Sea region and further north.[8]

The expert hunters and artists of St. Lawrence Island have been carving and incising ivory tools, hunting implements, and ceremonial implements for more than 2,500 years. Because local men, including members of Silook's own family, served as crew on many scientific excavations, and because many St. Lawrence islanders today dig informally at local archaeological sites, harvesting old ivory for reuse and resale, much more of this archaeological material is available for scrutiny by the local community than is usually the case elsewhere.[9] So Silook grew up with a familiarity with these ancient forms. In *Okvik Woman* (fig. 67), she makes reference to the so-called "Okvik Madonna" (named for the site at which it was excavated) and to other enigmatic female figures found at archaeological sites on St. Lawrence Island and elsewhere in north Alaska.[10]

Her ease with the formal language of ancient Arctic art is evident in the way she shapes her figures and ornaments their surfaces. For example, the striations and circles on the lower fishlike portion of the sea goddess's body evident in *Peaceful Sedna* and *Seeking Her Forgiveness* (fig. 65) are directly influenced by the surface patterning on Old Bering Sea and Ipiutak carvings of two millennia ago.[11]

The scale and shape of most of the artist's works are deliberately constrained to the size and circumference of one walrus tusk (which is usually no more than thirty inches long). Occasionally, she chooses to have the figures break out of their tusklike form through the addition of wings, pegged arms or flippers, or small hanging amulets (*Neghsaq*, fig. 66; *Yupik Angel*, fig. 70). In addition to being

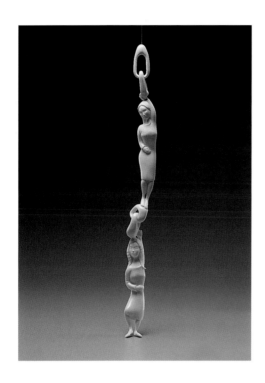

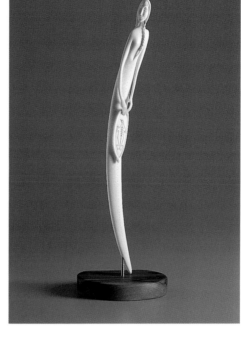

the heirs to a rich twenty-five-century-old local tradition, Silook's works evince an astute appreciation of world art. All are elongated figures of balletic grace, recalling Modigliani nudes or Léon Bakst's depictions of Diaghilev's dancers in the Ballets Russes.[12]

Sometimes her female figures are women in modern clothing. In an untitled piece from 1992 (fig. 63) each woman is suspended from chain links. This is an homage to the virtuoso ivory carving done in Alaska in the late nineteenth and early twentieth centuries, when much work was made for the burgeoning tourist trade; sometimes entire linked chains would be carved from one tusk.[13]

Iconographically, Silook's works mine ancient Eskimoan beliefs from throughout the Arctic; some exhibit a strong political consciousness as well. Silook's interest in the undersea goddess Sedna was sparked by reading the book *Powers Which We Do Not Know: The Gods and Spirits of the Inuit*,[14] in which many Sedna stories are related. (The theme of the wild and snappish undersea mistress of the animals is a familiar one in the Central Canadian Arctic, though not among the Siberian Yupik.) In the story, and in Silook's visual rendition of it, the female sea spirit releases sea mammals for human use only when a shaman travels down beneath the water to comb her wild and tangled hair and soothe her spirit.

In *Seeking Her Forgiveness* (fig. 65), a modern interpretation of the sea goddess's sorrowful face suggests that she is pondering the ecological disasters, polluted waters, and reduced numbers of marine mammals and fish that are the legacy of more than two hundred years of Euro-American presence in these northern waters. (This was a theme I heard several Alaskan Native artists, including

65. *Seeking Her Forgiveness.*
(See also p. x)

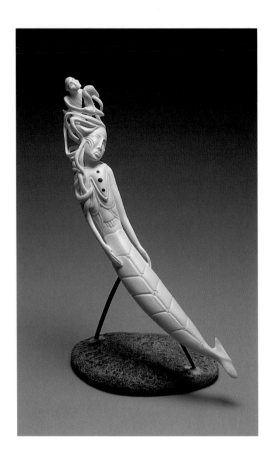

Silook, express in 1994 when I traveled in the North, just a few years after the Exxon Valdez disaster.) In *Peaceful Sedna* (1998), in contrast, her face is placid, her hair is combed, and the long locks end in the faces of small marine mammals.

In many cases, Silook exploits the inherent property of the walrus tusk, using to best advantage something that other carvers sometimes see as a liability: the fact that beneath the creamy white exterior of the ivory tusk lurks a more porous core material. Occasionally, Silook deliberately reveals this darker core in the torsos or limbs of her figures in order to provide both a color and textual contrast (e.g., *Okvik Woman*, fig. 67).

In the art of Susie Silook, style, subject matter, and material form a satisfying whole. Even the non-Native viewer who understands the long history of Arctic art, the rich hunting magic that traditionally underlaid such expressive works, and the current politics of ecological rights versus indigenous autonomy in the North may be challenged by subjects such as Sedna that embody a mythic narrative. Whalebone (the material she uses for many of her bases), walrus ivory, polar bear hair, and many other animal materials are regulated by the Marine Mammals Protection Act of 1972 and the Endangered Species Act of 1973. According to federal law, Alaska Natives who reside in Alaska may harvest such materials "for subsistence purposes or the creation and sale of Native articles of handicraft or clothing if the harvest is not wasteful." In addition, Natives may sell fossil ivory to non-Natives without first turning it into art or craft.[15] By depicting a figure such as Sedna, whose story tells of the withholding of

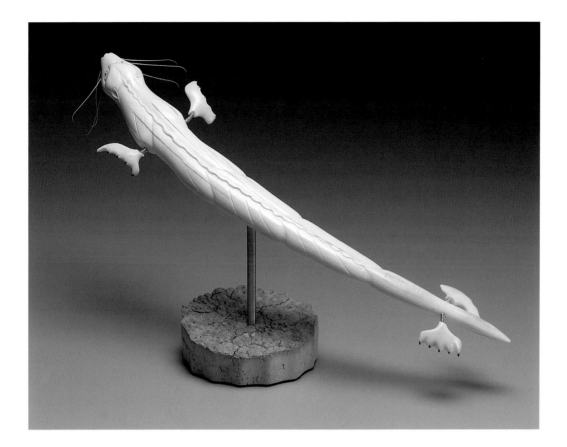

the richness of marine life to human beings, and by using materials from animals that have, indeed, diminished greatly in the last two centuries, the artist gives a polyvalent message to her audience; such multiple messages and images have long been a common feature of Arctic art.

Like Silook, many other contemporary Native artists in Alaska work in mixed media, often incorporating traditional materials from animals that are now protected by a morass of federal laws. Denise Wallace, an Aleut jeweler working in Santa Fe, for example, uses fossilized or archaeological walrus ivory as well as semiprecious stones and metals; sculptors Melvin Olanna, Lawrence Ahvakana, and Tom Yiulana use whalebone, walrus ivory, and feathers.[16] As Tlingit artist Jim Schoppert (1947–1992) once observed, "Just about everything we use is either protected, endangered, soon to be extinct, or illegal."[17]

Anti-Depression Ullimaaq (fig. 72) stands in contrast to the sleek, polished surfaces of Silook's other works shown here. Its unfinished surface is unpolished and still bears the rough marks of the carving knife. The piece is the bottom half of a tusk, from which the top half has broken off. The female figure herself holds a broken carving. Silook has written movingly about the genesis of this piece, carved during a period of "soul-sickness" in her life, when she retreated home to Gambell, feeling there like an "outsider-insider." The carving was resisting her efforts to complete it; it ultimately froze, and broke in two. The artist placed the top half in the coffin of her youngest brother Daniel, who had wanted to be an artist like his sister. She writes, heartbreakingly,

One day, the inevitable archaeologist is going to find his coffin with his bones and the ivory woman holding a comb. He will have to say that, although no documentation is available on the carving, the man must have been prominent and well-loved and important and highly esteemed to carry such a thing into the next world, given that he had lived and died at a time when such things, such things had been outlawed by God. It will be the one thing any archaeologist absolutely ever got right.[18]

Despite the discomfort she may feel at times on St. Lawrence Island—and in Anchorage—Silook scorns the tired rhetorical device of indigenous people's residence "in two worlds." Instead, she asserts, "I am able to participate in and become acquainted with many cultures, many views. Contrary to popular conception, I am not caught between two worlds. I am walking in many simultaneously."[19] So, too, her work partakes in many simultaneous worlds, conjoining poetic form and political commentary, bringing the visual language of the ancient Arctic into the twenty-first century, where it continues to speak to us of hunting magic and of ecological issues, of aboriginal identity and autonomy, of female power and the eloquent power wielded in a carver's hands.

Notes

1. See, e.g., her untitled 1992 work depicting a crucifix emerging from a split Yupik mask, in Fred Nahwooksy and Richard Hill, Sr., ed., *Who Stole the Tee Pee* (New York: Atlatl and the National Museum of the American Indian, 2000), plate 10; and "Mask of Post-Colonization Tupilaks," in Jan Steinbright and Caroline Atuk-Derrick, eds., *Arts of the Arctic* (Anchorage: Anchorage Museum of History and Art, 1992), plate 15.

2. Silook's poetry has been published in Ronald Spatz, ed., *Alaska Native Writers, Storytellers, and Orators* (Anchorage: Alaska Quarterly Review, 1999): 245–53; "Points North: the Arctic Circle," *Nimrod International Journal* 38, no. 2 (1995): 40–43; and numerous issues of the *Journal of Alaska Native Arts* (Fairbanks).

3. St. Lawrence islanders (who are known as Siberian Yupik to distinguish them from the Yupik of southwestern Alaska) share a linguistic and cultural affiliation with Asiatic rather than North American Eskimoan peoples. See Charles C. Hughes, "St. Lawrence Island Eskimos," in William C. Sturtevant, ed., *Handbook of North American Indians*, vol. 5 (Washington, D.C.: Smithsonian Institution, 1984).

4. Roger Silook, *Seevookuk: Stories the Old People Told on St. Lawrence Island* (Anchorage: privately printed, 1976). Her grandfather, Paul Silook, whom she considers a "Native ethnologist," was described by an archaeologist who worked with him as "a literary man" who learned a flowery and eloquent English by working for missionaries, and served as an interpreter and archaeological fieldworker. He worked with both Henry Collins and J. Louis Giddings in the 1930s. See J. L. Giddings, *Ancient Men of the Arctic* (Seattle: University of Washington Press, 1967), 167–69.

5. While female ivory carvers are rare, they are not unknown. See the interview with Myrtle Booshu of St. Lawrence Island by Roy Johnson, "Profiles of Four Ivory Carvers," in Dinah Larsen and Terry Dickey, eds., *Setting It Free: An Exhibition of Modern Alaskan Eskimo Ivory Carving* (Fairbanks: University of Alaska Museum, 1982), 42–44.

6. All quotes from the artist, unless otherwise identified, are taken from interviews conducted by the author in Alaska during the summer of 1994, or by telephone in December 2000.

7. Discussions of the material culture of St. Lawrence Island can be found in Roger Silook, *Seevookuk*; and Charles C. Hughes, "St. Lawrence Island Eskimos." For an account of an old-fashioned walrus hunt, see Roger Silook, 30–34.

8. See Henry Collins, "Archaeology of St. Lawrence Island, Alaska," *Smithsonian Miscellaneous Collections* 96, no. 1 (1937); and Otto Geist and Froelich Rainey, *Archaeological Excavations at Kukulik*, St. Lawrence Island, Alaska, Miscellaneous Publications of the University of Alaska (Fairbanks: University of Alaska, 1936). A general survey of Arctic ivory can be found in J. G. E. Smith, *Arctic Art: Eskimo Ivory* (New York: Museum of the American Indian, 1980).

9. See David Staley, "St. Lawrence Island's Subsistence Diggers: A New Perspective on Human Effects on Archaeological Sites," *Journal of Field Archaeology* 20, no. 3 (1993): 347–54.

10. The "Okvik Madonna" is illustrated in Aldona Jonaitis, ed., *Looking North: Art from the University of Alaska Museum* (Fairbanks: University of Alaska Museum, 1998), plate 25. See also George Shaw, *Art of Grace and Passion: Antique American Indian Art* (Aspen, Colo.: Aspen Art Center, 1999), plate 93.

11. See, e.g., the ancient ivories in Janet C. Berlo and Ruth Phillips, *Native North American Art* (Oxford: Oxford University Press, 1998), figs. 100–102; and Gilbert Vincent, Sherry Brydon, and Ralph T. Coe, eds., *Art of the North American Indian* (Seattle: University of Washington Press, 2000), 420–24.

12. See Doris Krystof, *Amadeo Modigliani, 1884–1920: The Poetry of Seeing* (New York: Taschen Books, 2000); and Arsène Alexandre, *The Decorative Art of Leon Bakst* (New York: Dover Publications, 1972).

13. See, e.g., J. G. E. Smith, *Arctic Art*.

14. Daniel Merkur, *Powers Which We Do Not Know: The Gods and Spirits of the Inuit* (Moscow, Idaho: University of Idaho Press, 1991).

15. These laws are well known in Alaska and are posted on the website of the U.S. Fish and Wildlife Service (www.r7.fws.gov/mmm/faq). See also Janet Berlo, "Material Issues: The Impact of Regulation on Native Art," a review essay in *Inuit Art Quarterly* 9, no. 4 (1994): 36–40.

16. On Denise Wallace, see Carolyn Benesh, "Spirits and Souls: Denise and Samuel Wallace," *Ornament* 15, no. 2 (Winter 1991): 44–49. Works by Olanna, Ahvakana, and Yiulana are pictured in Steinbright and Atuk-Derrick, eds., *Arts of the Arctic*.

17. "Between the Rock and the Walrus: An Essay on Being a Native Artist," in Kesler Woodward, ed., *Wood Ivory and Bone*, 1981 Native Art Competititon (Juneau: Alaska State Museum, 1981), 7.

18. S. Silook, "The Anti-Depression Uliimaaq," in Spatz, ed., *Alaska Native Writers*, 248.

19. Artist's statement for entry into Eiteljorg Museum competition, 2000.

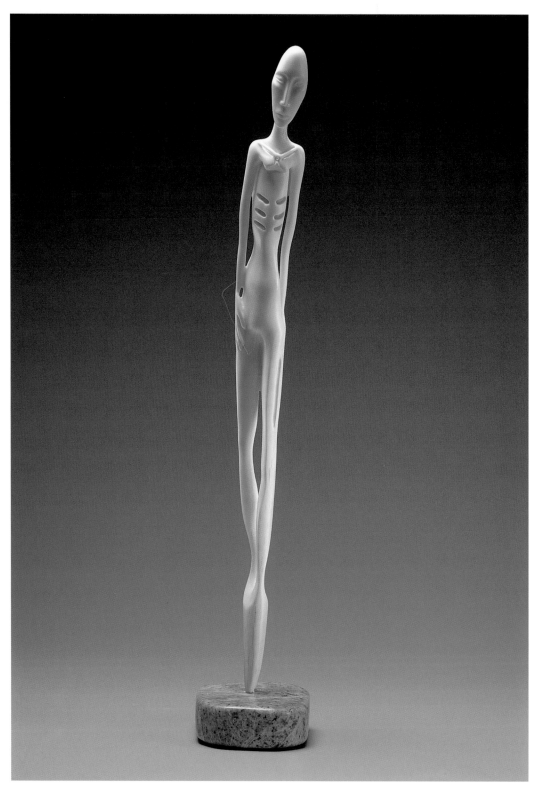

67. *Okvik Woman*

Susie Silook

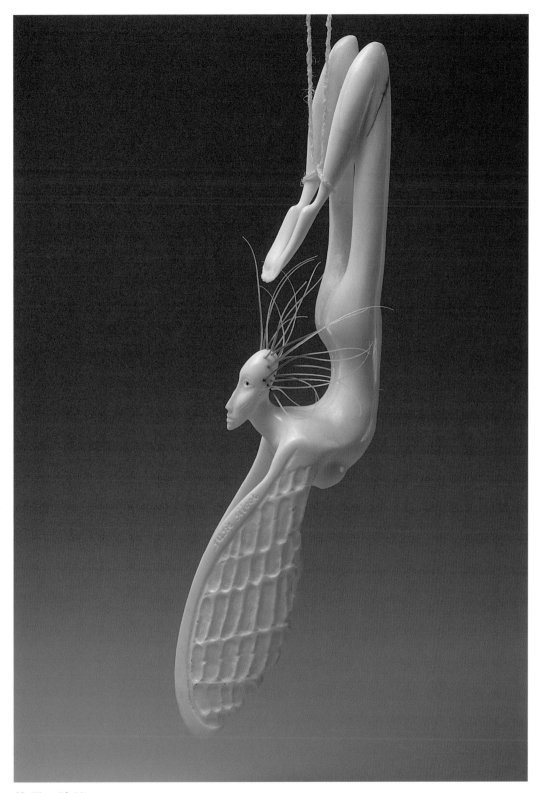

68. *Winged Spirit*

"Simultaneous Worlds"

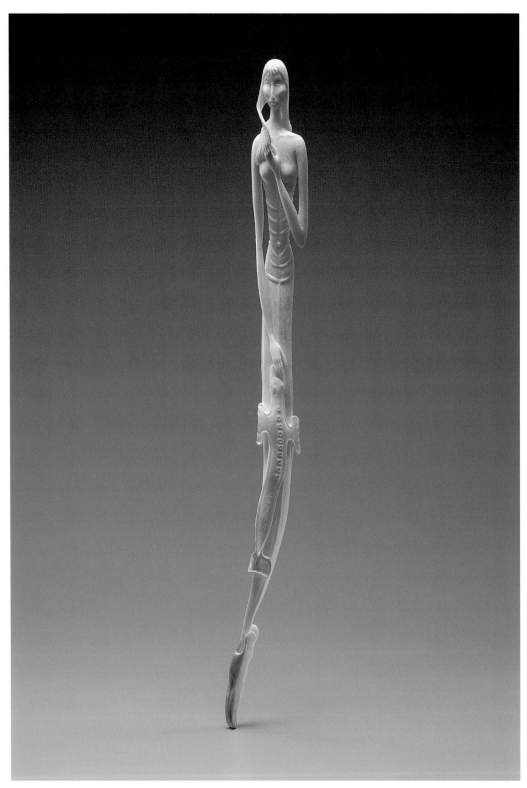

69. *Sedna*, 70. *Yupik Angel*

Susie Silook

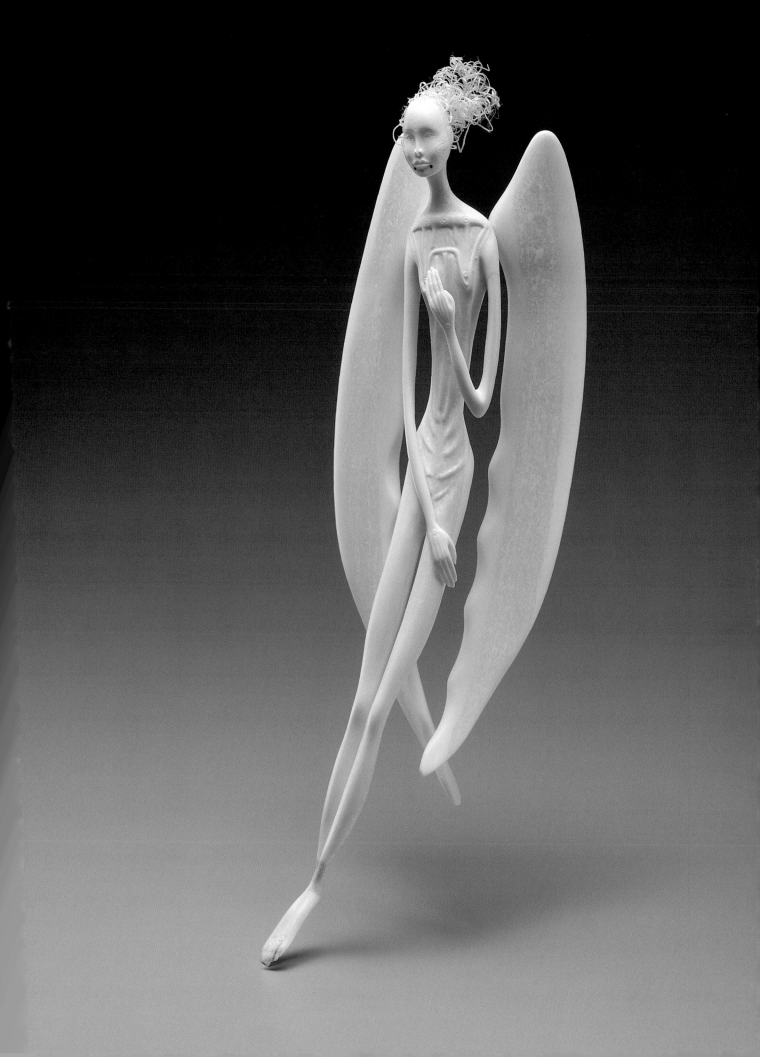

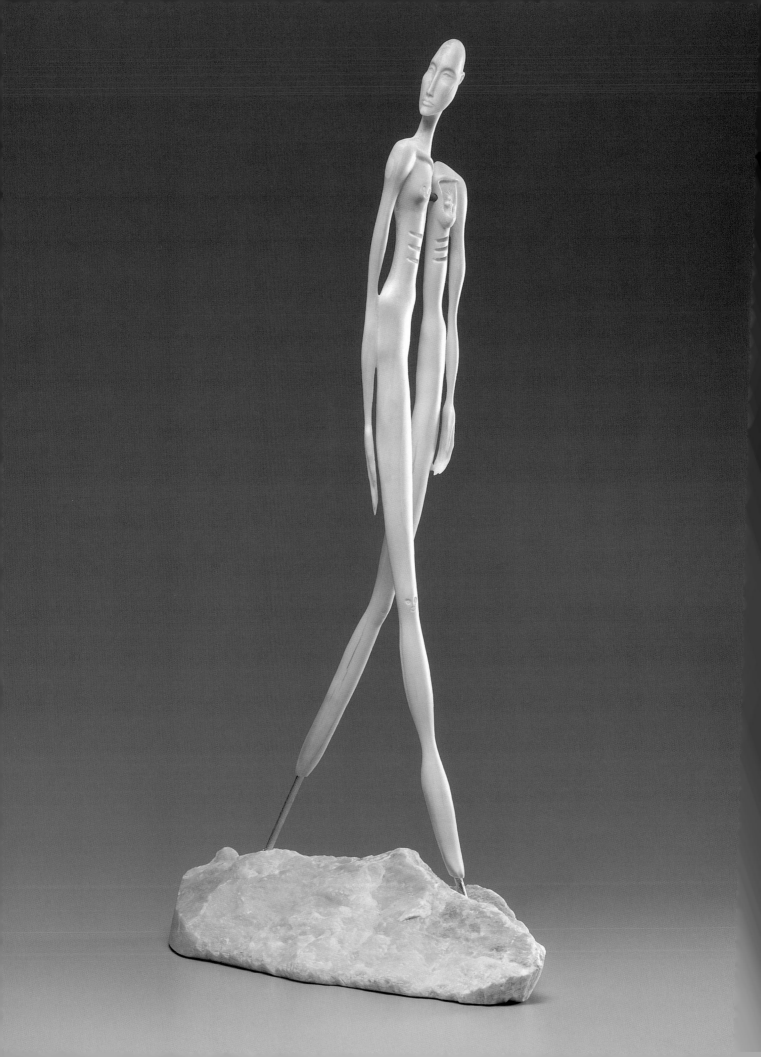

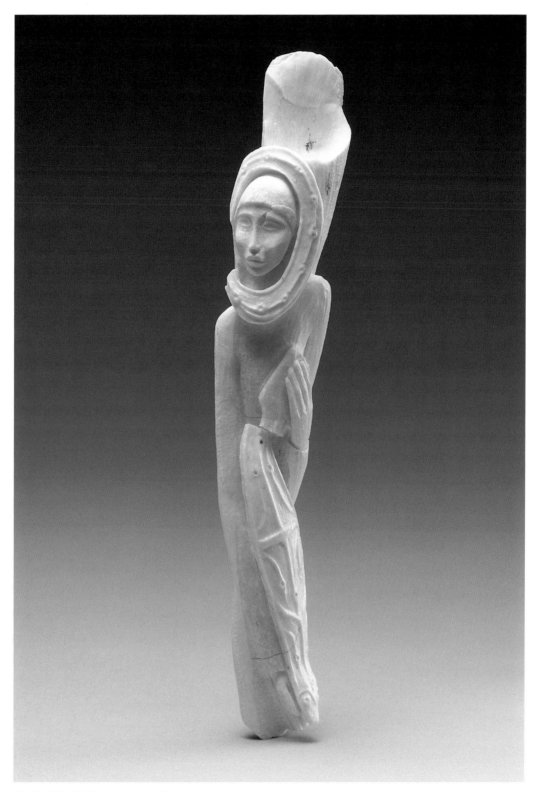

71. *The Walk,* 72. *Anti-Depression Ullimaaq*

"Simultaneous Worlds"

Janet Catherine Berlo is Susan B. Anthony Professor of Gender and Women's Studies and professor of art history at the University of Rochester, in New York. Her most recent books include Spirit Beings and Sun Dancers: Black Hawk's Vision of a Lakota World (2000) and Native North American Art (1998).

Colleen Cutschall (Lakota) is professor and coordinator of visual art at Brandon University in Brandon, Manitoba. Her paintings and multimedia installations have appeared in numerous solo exhibitions, including Voice in the Blood (1990) and House Made of Stars (1996).

Lee-Ann Martin (Mohawk) is an independent curator and critic who was previously head curator at the MacKenzie Art Gallery in Regina, Saskatchewan, and curator-in-residence for contemporary Indian art at the Canadian Museum of Civilization. She is the author of numerous exhibition catalogs, including Alex Janvier: Negotiating the Land (1994) and, with Gerald McMaster, INDIGENA: Contemporary Perspectives (1992).

Carol Podedworny is director and curator of the University of Waterloo Art Gallery in Waterloo, Ontario. She has curated many exhibitions featuring contemporary First Nations artists, including "(An)Other Canada: Janet Anderson, Rebecca Belmore, Laura Millard, Sylvie Readman" (1999) and "Language of Culture: Carl Beam, Andy Fabo, Shelagh Keeley, John Scott" (1994), and is the coauthor of Daphne Odjig: 1966–2000 (2001) .

W. Jackson Rushing III is professor of art history and chair, Department of Art, at the University of Houston. His publications include Native American Art and the New York Avant Garde (1995); (as coauthor) Modern by Tradition (1995); and, as editor, Native American Art in the Twentieth Century (1999).

Exhibition
Checklist

Allan Houser

1. Buffalo Hunt
 Gouache and watercolor
 on paper
 1952
 17 1/4" x 26 1/4"
Courtesy of Arthur and Shifra Silberman
 Collection, National Cowboy
 and Western Heritage Museum,
 Oklahoma City
Photo courtesy of National Cowboy and
 Western Heritage Museum

2 a,b. Two-Sided Pen-and-Ink Drawing
 Graphite and ink on paper
 Ca. 1965
 23 1/2" x 35"
Courtesy of Allan Houser Inc.

3. Reservation Romance
 Pink Tennessee marble
 1980
 24" x 9" x 9"
Courtesy of Sonja Eiteljorg

4. Silent Observer
 Bronze, edition 12/12
 1985
 19" x 18" x 12"
Courtesy of Ted and Steve Wymer

5. Options II
 Bronze, edition 6/30
 1992
 6" x 6" x 6", each of 2 elements
Courtesy of Allan Houser Inc.

6. Migration
 Bronze, edition 5/10
 1992
 62" x 38 1/2" x 37"
Courtesy of Allan Houser Inc.

7. Smoke Signal
 Bronze
 1993
 57" x 23" x 31"
Courtesy of National Cowboy and West-
 ern Heritage Museum, Oklahoma City
Photo courtesy of National Cowboy and
 Western Heritage Museum

8. Apache Ga'an Dancer
 Charcoal and pastel
 on paper
 1994
 38" x 50"
Courtesy of Mrs. Anna Marie Houser
 /The Allan Houser Foundation
Photo by James Hart
 Photography, Santa Fe

9. Corngrinder
 Bronze
 1994
 28" x 21" x 42"
Courtesy of Allan Houser Inc.

10. Earth Mother
 Bronze, artist's copy
 1986
 41" x 28" x 25"
Courtesy of Mrs. Anna Marie Houser/
 The Allan Houser Foundation
Photo by Wendy McEahern, Santa Fe

11. Drama on the Plains
 Stone
 1977
 21" x 27" x 8 3/4"
Courtesy of Buffalo Bill Historical
 Center, Cody, Wyo.
William E. Weiss Contemporary Art Fund
Photo courtesy of Buffalo Bill
 Historical Center

Rick Bartow

12. Blind One of Assarow
 (Fintan—Ireland)
 Pastel, graphite, and charcoal
 on paper
 1999
 40" x 26"
Courtesy of Froelick Gallery,
 Portland, Ore.

13. Fox Spirit
 Mixed media
 2000
 20" x 25" x 9"
Courtesy of Froelick Gallery,
 Portland, Ore.

14 a,b. Cultural Hero
 Mixed media
 1998
 48" x 11" x 11"
Courtesy of Froelick Gallery,
 Portland, Ore.

15. Brush with Death
 Mixed media
 2000
 14" x 3" x 3"
Courtesy of Froelick Gallery,
 Portland, Ore.

16. Aggie II
 Mixed media
 2000
 8" x 4" x 4"
Courtesy of Froelick Gallery,
 Portland, Ore.

17. After Vermeer
 Girl in Red Hat
 Pastel and graphite on paper
 1998
 44" x 27"
Courtesy of Froelick Gallery,
 Portland, Ore.

18. After Vermeer
 Girl with Pearl Earring
 Pastel and graphite on paper
 1998
 44" x 31"
 Courtesy of Froelick Gallery,
 Portland, Ore.

19. Crow Hop
 Pastel and graphite on paper
 1990
 40" x 26"
 Courtesy of Froelick Gallery,
 Portland, Ore.

20. Coyote Mask
 Pastel on paper
 1995
 40" x 26"
 Courtesy of Froelick Gallery,
 Portland, Ore.

21. Now Hanniya
 Pastel and charcoal on paper
 1998
 44 $^1/_2$" x 30 $^1/_2$"
 Courtesy of Froelick Gallery,
 Portland, Ore.

22. Crow Talk
 Pastel and graphite on paper
 1998
 45" x 31"
 Courtesy of Froelick Gallery,
 Portland, Ore.

23. Big Otsue
 Pastel and charcoal on paper
 1998
 44 $^1/_2$" x 30 $^1/_2$"
 Courtesy of Froelick Gallery,
 Portland, Ore.

24. Selbst II
 Pastel and graphite on paper
 1998
 40" x 26"
 Courtesy of Froelick Gallery,
 Portland, Ore.

25. Biting Through 3
 Pastel, graphite, and charcoal
 on paper
 1999
 40" x 26"
 Courtesy of Froelick Gallery,
 Portland, Ore.

26. 28 + 13 Selbst
 Pastel, graphite, and charcoal
 on paper
 1999
 40" x 26"
 Courtesy of Froelick Gallery,
 Portland, Ore.

27. Gabriel's Struggle
 Pastel, graphite, and charcoal
 on paper
 1999
 40" x 26"
 Courtesy of Froelick Gallery,
 Portland, Ore.

Joe Feddersen

28. Pin Wheel
 Pencil drawing on paper and wax
 1996
 5" x 4 $^1/_2$" x 4 $^1/_2$"
 Courtesy of the artist

29. Grandmother's Basket
 Waxed linen with
 white horse hair, lined with cloth
 1996
 2 $^3/_4$" x 20 $^1/_2$" x 2 $^3/_4$"
 Courtesy of the artist

Black Haired Basket
 Waxed linen with black horse hair
 1999
 3 $^3/_4$" x 19" x 3 $^3/_4$"
 Courtesy of the artist

30. Target Basket
 Waxed linen trimmed with ribbon
 1999
 4 $^3/_4$" x 4" x 4"
 Courtesy of the artist

31. Red Treasure Basket
 Wool lined with cloth
 1994
 3 $^3/_4$" x 3 $^1/_2$" x 3 $^1/_2$"
 Courtesy of the artist

32. Multi Colored Basket
 Tapestry wool linen with cloth
 1994
 6" x 5 $^1/_2$" x 5 $^1/_2$"
 Courtesy of the artist

33. Plateau Geometric 88
 Monoprint
 1997
 12" x 12"
 Courtesy of the artist

34. Plateau Geometric 98
 Monoprint
 1997
 12" x 12"
 Courtesy of the artist

35. Plateau Geometric 128
 Monoprint
 1998
 12" x 12"
 Courtesy of the artist

36. Plateau Geometric 129
 Monoprint
 1998
 12" x 12"
 Courtesy of the artist

37. Plateau Geometric 149
 Monoprint
 1999
 12" x 12"
 Courtesy of the artist

38. Plateau Geometric 169
 Monoprint
 2000
 12" x 12"
 Courtesy of the artist

39. Plateau Geometric 175
 Monoprint
 2000
 12" x 12"
 Courtesy of the artist

40. Plateau Geometric 180
 Monoprint
 2000
 12" x 12"
 Courtesy of the artist

41. Plateau Geometric 185
 Monoprint
 2000
 12" x 12"
 Courtesy of the artist

42. Plateau Geometric 190
 Monoprint
 2000
 12" x 12"
 Courtesy of the artist

43. Plateau Geometric 192
 Monoprint
 2000
 12" x 12"
 Courtesy of the artist

44. Plateau Geometric 194
 Monoprint
 2000
 12" x 12"
 Courtesy of the artist

45. Plateau Geometric 196
 Monoprint
 2000
 12" x 12"
 Courtesy of the artist

46. Plateau Geometric 197
 Monoprint
 2000
 12" x 12"
 Courtesy of the artist

47. Blue Chevron
 Silography—relief
 2000
 16" x 22"
 Courtesy of the artist

48. Blue Chevron II
 Silography—relief
 2000
 16" x 22"
 Courtesy of the artist

Teresa Marshall

49. Metissage
 Cedar, tobacco,
 4 stone needles
 1995
 51 ¹/₂" x 138" x 138"
 Courtesy of the artist

50. Bering Strait Jacket #1
 Men's straightjacket,
 men's pants, silk scarf, acrylic paint
 1994
 68" x 28" x 2"
 Courtesy of the artist

51 a,b.
 Bering Strait Jacket #2
 Men's silkscreened straightjacket,
 beaded hanger, silk scarf
 1995
 34" x 27" x 2"
 Courtesy of the artist

52. Pressing Issues
 Stretched rawhide, wood, metal,
 leather, ivory
 1998
 96" x 118" x 54"
 Courtesy of the artist

53. Moccasin Telegraph
 Hide-bound phone
 with table
 1996
 48" x 12" x 12"
 Permanent collection of St. Francis
 Xavier University, Antigonish, Nova
 Scotia. Purchased with financial
 support of the Canada Council for the
 Arts Acquisition Assistance Program

Shelley Niro

54. For Fearless and Other Indians
 Color photo installation
 1998
 48" x 280"
 Courtesy of the artist
 Photo courtesy of Indian Art Centre,
 Dept. of Indian and Northern Affairs

55. Unbury My Heart
 Mixed media
 2000
 88" x 204" x 48"
 Courtesy of the artist
 Photo by Isaac Applebaum, Toronto

56. Tutela
 Acrylic on canvas
 (three-panel installation)
 1992
 60" x 120"
 Courtesy of the artist

57. Final Moments
 Thinking of You
 Color photo installation
 1998
 160" x 90"
 Courtesy of the artist

58. I Sat on a Riverbank and Waited
 for Signs of Life
 Velvet, beadwork, rocks
 1999
 3 $^1/_2$" x 10" x 10"
 Courtesy of the artist

59. One Day in March
 Velvet, beadwork, rocks
 1999
 2" x 8" x 10 $^1/_2$"
 Courtesy of the artist

60. Erratic Love Song
 Velvet, rock, poetry by
 Daniel David Moses
 1999
 4" x 43" x 41"
 Courtesy of the artist

61. Here
 Wooden box, beadwork, mirror,
 stone, feather
 1994
 2 $^3/_4$" x 14" x 14"
 Courtesy of the artist

The following three films were included
in the 2001 Eiteljorg Fellowship exhibi-
tion but are not illustrated here:

Honey Moccasin 1998
 A Shelley Niro Film
Written and directed by Shelley Niro
Produced by Lynn Hutchinson and
 Shelley Niro
Courtesy of the artist

It Starts with a Whisper 1993
 A Bay of Quinte Production
Written, directed and produced by
 Shelley Niro and Anna Gronau
Courtesy of the artist

Overweight with Crooked Teeth
 1996
 Film
Written, directed, and produced by
 Shelley Niro
Based on the poem "Overweight with
 Crooked Teeth" by Michael Doxtater
Courtesy of the artist

Susie Silook

62. Untitled, standing figure with
 figures emerging from head
 Ivory, whalebone
 1993
 18 $^1/_2$" x 6 $^3/_4$" x 6 $^3/_4$"
 Courtesy of Mrs. Edward R. Clinton

63. Untitled, chain figures
 Ivory
 1992
 18" x 2" x 2"
 Courtesy of Mrs. Edward R. Clinton

64. Waiting
 Ivory, red ochre
 1994
 16 $^1/_4$" x 1 $^1/_2$" x 1"
 Courtesy of Mrs. Edward R. Clinton

65. Seeking Her Forgiveness
 Ivory, whalebone, baleen
 1992
 12" x 15" x 5"
 Courtesy of Petro Star Inc., a division of
 Arctic Slope Regional Corporation

66. Neghsaq
 Ivory, baleen, seal whiskers, brass
 2000
 19" x 5" x 1 $^1/_2$"
 Courtesy of Boreal Traditions,
 Anchorage

67. Okvik Woman
 Ivory
 2000
 19" x 2" x 1"
 Courtesy of Boreal Traditions,
 Anchorage

68. Winged Spirit
 Ivory, seal whiskers, sinew
 1994
 10" x 2" x 2 $^1/_2$"
 Courtesy of Cathy Rasmuson

69. Sedna
 Ivory
 1995
 21" x 2" x 1"
 Courtesy of Cathy Rasmuson

70. Yupik Angel
 Ivory, whale sinew, baleen
 1994
 14" x 4 $^1/_4$" x 4 $^1/_4$"
 Courtesy of the artist

71. The Walk
 Ivory, purple heart, brass, alabaster
 2000
 25 $^1/_2$" x 6" x 4 $^1/_2$"
 Courtesy of the artist

72. Anti-Depression Ullimaaq
 Ivory
 1993
 9 $^1/_2$" x 2" x 1 $^1/_4$"
 Courtesy of the artist